Dedalus Original Fiction in Paperback

BAD TO THE BONE

James Waddington is a playwright based in the North of England who divides his time between writing and cycling.

Bad to the Bone is his first novel.

D1102823

James·Waddington

Bad to the Bone

Dedalus

Eastern Arts
Board Funded

Published in the UK by Dedalus Ltd, Langford Lodge, St Judith's Lane, Sawtry, Cambs, PE17 5XE

ISBN 1 873982 68 2

Dedalus is distributed in the United States by Subterranean Company, P.O. Box 160, 265 South Fifth Street, Monroe, Oregon 97456

Dedalus is distributed in Australia & New Zealand by Peribo Pty Ltd, 58 Beaumont Road, Mount Kuring-gai, N.S.W. 2080

Dedalus is distributed in Canada by Marginal Distribution, Unit 102, 277 George Street North, Peterborough, Ontario, KJ9 3G9

First published by Dedalus in 1998
Bad to the Bone copyright © James Waddington 1998

Typeset by RefineCatch Ltd, Bungay, Suffolk
Printed in Finland by Wsoy

To Judith

*"It's very difficult to describe and maybe it's
something you have to experience, but suffering
very badly — and it never looks the same on
television, even for me watching it looks very fluid
and the riders are just climbing the mountains —
but the suffering side of it, when you think 'I've
just got to get another hour and a half of this climb,
and then there's another ten days,' that's what
sees people finished off. You've just had enough of
suffering because you can't take any more."*

Chris Boardman,
Channel 4 interview, 10 July 1996

Prologue

There is a man in Finland who anonymises E-mail for you. Its source becomes untraceable. To make it a waste of time anyone asking him questions, the whole process is done by software without having to pass through his brain. The software deletes each process from the hard disc once it is complete. The software has special anti-undelete properties.

The man in Finland's computer is like a little gap in space/time. There is no point in torturing him or threatening him with the law if he doesn't disclose information. He doesn't have it.

What he does is quite legal in Finland.

Of course this is a lot of words for an E-mail. I have tried to keep it as short as possible. I know the Internet is not a comfortable place for reading, more for looking and doing. I compiled the document, cut it down as much as I could, then transferred it to the man in Finland. I didn't encrypt it because those who watch over us keep encrypted files to unlock later if possible, whereas something that looks like a made-up story will be automatically deleted within seven days at the most.

The man in Finland installed the file in three directories in three anonymous FTP sites – one in Finland, one in Germany, one in the USA. In case you don't know, an anonymous FTP site is one from which anyone with a computer and a modem can fetch files. Complicated? A thousand times less than knitting a glove.

These files were marked with ON NO ACCOUNT TO BE DELETED. So someone might by and by have a look, say what the hell is this that is on no account to be deleted.

My gain is that this story is out there somewhere. For me, anonymous like the FTP, it is important that it is heard, if only because we cannot be sure that it is all finished with, that those are dead who should be and that which is destroyed should not be re-invented.

My loss is that someone may see the chance to make a bit of

money from my labours. If you there, reading this, are what they call a 'general reader', then someone has already done so. If on the other hand you are a cyber-surfer who has just downloaded it by mistake and are thinking what the fuck is this? – pause a moment. If you're the first, we could be doing each other a favour. I assign copyright to you, and you alone.

By the by, what a patronising term 'general reader' is. You may share with this story a fascination with love, with good and evil, with ambition, with curiosity, with anxiety about the future of us all, but the way these things mix with your own life, your own story – unique is too trite a word. Unique reader, I salute you!

Stage 1

The first thing that happened was that Jan Potocki's body vanished. It could be asked whether he was using it at the time. Even so, it was hard to see why anyone should need it more than Jan. It was lying before it disappeared in the most up to date intensive care unit in Grenoble. Some of Jan's Catholic fans, they put forward the theory that he had been taken up into heaven. The Vatican through an anonymous spokesman said they saw little reason why heaven should require Potocki's biological remains. Madame Potocki was understandably upset by his vanishing. Her way of dealing with it was to wail a lot. This with the black scarf and mouth not jammed open too wide looks suitable in photos, but it gets on the nerves when you have the sound track as well.

Jan was in the clinic because he had bashed his head. At the moment he bashed it he was one of the best professional cyclists in the world. But once the mind goes missing, the body starts to deteriorate.

There are long distance swimmers, women who climb Everest alone, there are people with very big muscles who run the hundred metres while you blink. But nothing requires as much sustained power as a three week bike race. Nobody argues about that. To fuel this energy, the riders eat huge amounts of scientifically balanced diet, but by the third week when they are in the high mountains the body is just too hungry, no food can keep it satisfied. It begins to eat itself. The racing cyclist's body can lose between one point five and two kilograms of muscle in the third week of the Giro or the Tour de France.

The third week. That's when the great Potocki was brought to the clinic by helicopter, out of it. Out of the Tour and out, for sure, of his head. The skull was there and apparently in its usual shape, but no tenant.

There is a clinician's photo of Jan on that day, lying on his

11

back on a bed which resembles a plinth or a tomb. Naked, he is still dressed like a cyclist in the silver absence of his tan.

The eyes are open and empty. But, creepy thing, the muscle tone is of a man who is at the peak of his form before the contest begins, sleek, almost plump with fibre. How is this, in the last week of the Tour de France, when this weary engine should be far past its peak tune, the muscles knotty and dented from being too long on the edge of agony and exhaustion.

The clinician's photo on the third day shows a man in even better shape. It seems that from intravenous nutrition alone the muscles have fattened themselves up, flossed more silky, curvier. The eyes alas are still empty.

On the twenty-first day the main cycling muscle groups like vastus and rectus femoris, the bulges that stand out along the front of the thigh, are enormous — they look like they're going to split, pupate perhaps and little muscles come creeping out. But all around is a sort of decay like you get in the catacombs, like the last stages of cancer. The nose is a frail beak. The skin doesn't mould the face any more but stretches dangerously between the bones. This body has not moved, has not twitched for three weeks.

There is no photo for the twenty-second day. If there were, it would show an empty bed. But some time in the night Jan's body has gone. The clinic authorities said it was a complete mystery, they had state of the art electronic security, backed up by trained and trustworthy security personnel. There had been no suspicious circumstances — nothing on the surveillance monitors, nothing on the entry sensors, no traffic movement. The unit had been max. secure from 2100 until the police arrived at 0311. At 0257 the duty nurse on intensive care had gone to the toilet and returned at 0303 to find the bed empty. She had immediately phoned the duty manager, and the police were there, as has already been said, by 0311. The correct procedures were carried out with maximum efficiency.

Jan's body has never been found.

Stage 2

Jan crashed out because of a frog. This is unusual. It was the year the great Akil Sáenz won his fifth Tour de France, equalling the record.

Most cyclists only look good when they're on a bike. A top rank cyclist gets off the bike and he looks like a chicken. It's because he has these developed thighs, and the relaxed muscle almost overhangs the knee. And then below the thighs, where the feathers would come to an end on your chicken, he has these fine lightweight calves. See, the calves are not the engine. The engine is in the heart, the lungs, the ass, the thighs. The calves merely articulate the engine to the machine. The man doesn't want to carry extra meat over the mountain.

Akil, however, it's got to be said, he looked good off the bike. He was, in my opinion, rather overburdened with grace, that guy. He even got in Vogue magazine – more power to him, and all good for the sport – but he already had the distinction of being the most powerful engine cycling has seen. With the kind of money that brings in it wouldn't have done him any harm to look like the Hunchback of Notre Dame. But no, he is six foot three, and his hair is bronze-gold, and his skin is also bronze. (All this comes from Vogue magazine, I never noticed myself.) Many people from that part of the country they are this way, but there is talk also of some montagne African blood, some two-thousand-metres-above-sea-level-ancestry much closer to the equator. Personally I think this is bollocks. The journos, you know, must have their myth.

So, according to Vogue, he has 'legs like a gazelle's, tapering from extravagantly muscled thighs to long sharp-thewed shanks and girlish ankles. His resting heart beats only once every two seconds and his lungs are twice the effective size of the deskbound commuter's.'

They are not entirely besotted by his physique. They do point out that the perfect taper of his finely muscled torso,

cinnamon-gold it goes without saying and without a hint of spare flesh oh yeah dooby dooby, is marred by a bulge below the ribcage. Hernia? A secret lager habit? No, it's where he keeps the extra of his huge lung capacity. It's nothing special. All top cyclists have it, like the bulges under the bonnet of old fashioned race cars where they couldn't quite fit the supercharger into the aerodynamics.

But apart from that, just to finish off with Vogue, he has 'crocus mauve' eyes and the features of – and then a paragraph creaming themselves over the fantasy of how some Nordic Hollywood hunk on steroids could'a spent a night of love with an Abyssinian catwalk superstar young enough to be Akil's little sister. Eugenics and incest, don't it make the bourgeois heart go pit-a-pat.

It is hoped the picture is beginning to paint itself.

But it is necessary to admit that there was some magic about him. When he looked down on a room of ordinary mortals in the clothes of the daily world, from under his gold-bronze hair and out of his damned 'crocus mauve' eyes, it wasn't just the women who had a sensation of loss.

The day Jan hit his head. The peloton is polyglot. I try to do it like Akil might have seen it.

<p style="text-align:center">*</p>

Lay-by, I Sáenz make the hand signal, the whole peloton swings in, dismounts, one hundred and eighty seven streams of piss hit the verge.

One hundred and eighty six. Potocki is disappearing alone around the far bend.

It is permissible tactics.

But. Jan Potocki is the rider most dangerous to me at this point in history.

Jan is not a pure climber. He is not one of those little spider men whose lungs are helium balloons, who when they ride up a ten per cent gradient have only the wind to contend with, because they are immune to gravity. Pure climbers suffer descending. Then they are like feathers trying to hurtle. They have not so much overall power.

I Sáenz, like the eagle I close my wings and I hurtle like a rock.

But I cannot waft like Peluso wafts, turning the big gears, floating above the cranks.

Sáenz, a man of power, he has to find the notch.

With your car climbing an Alpine pass there is a combination of revs and gear where the turbo is blowing full. Your foot is flat against the floor, but everything is in balance, power, torque, aspiration. That is Sáenz. I ride the hills on such a balance, on the notch. Surfing on the huge flow of blood and oxygen, I rhythmically drive this body of the gods which I inhabit to the summit. Then, like a thunderbolt, I descend.

But it is not Peluso the specialist climber who has gone up the road while the rest are taking a piss. It is Jan Potocki. Potocki is not a specialist climber. He also is a man of power.

History tells us that I Akil Sáenz can crush such moves. I bear down upon the fugitive like a hunting dog on a rabbit. My rival senses it even before he sees my shadow, his spirit is broken as sharply as if it were his back.

That is at least how things should be. But something has got into Potocki, literally it seems – something sent to unsettle Sáenz. Potocki is not the man he was. He speaks more than the usual rubbish, is lost so deep in himself that he blunders into fixed objects, cannot remember what day it is, what mountain we are climbing. Fuck, who cares about the mind of Potocki. But the strange thing is, this confusion of mind seems to have given his body gratuitous strength. An extraordinary strength.

These are quick thoughts. The gutter streaming with coureurs' piss, I remount in restrained haste. A clutter of Cosimo domestiques and other nobodies try to upset us with rabble. I call my team behind me. With head high and peak of casquette pulled down – the eyes in shadow staring down from above signify authority – I scatter the peloton to each side by force of will as I ride to the front. This is Sáenz. If they did not part before him his front wheel might touch the rear of one of these, and the eagle would be sprawling in the dirt, cut and perhaps with a wing shattered. Such a dishonour and a crime they dare not contemplate.

We ride at the head for some minutes, screwing the pace ever higher. For the moment it is my domestiques at the front in line of four, and on the second rank my lieutenants, Patrul, Menaleon, Agaxov. I ride

with them at an easy gait – yes for me this withering speed is an easy gait, a rhythmic pulse of power that has no end to it. However, back down the road already there will be weaker bodies suffering, so exhausted with two weeks' riding that they are overcome with the sensations of illness, like flu. They struggle and suffer, waver and pant and sweat and then suddenly, as if the bicycle had a mind of its own, it swoops and flutters to the side of the road and they have to twist their feet from the pedals quick before the asphalt smacks them. Then they weep.

Sáenz cares little for them. This time I have worries of my own. Ten minutes have passed. I am aware of Sarpedón, Baris, Arkhangelski trying to be invisible a few ranks behind me. They are Jan's men, and they are watching me. They are watching for me and my lieutenants to explode from the front of the group like hunting barracuda out of a shoal of fry.

Sarpedón, Baris, Arkhangelski. A pod of the flesh-eating killer whales that hunt in silence.

Patrul, Patrul Azafrán my trusted compañero, is at my right elbow. I turn for a fraction of a second and look him in the eye. I signal Agaxov to come up on my other side so we ride like one, we three, Sáenz, Azafrán, Agaxov. And Jan's men, the Cosimos, they watch us.

Out of the blue, so even me, I start with surprise, Azafrán rises on the bars, tilts back his head and roars like an ejaculating bull. Then he ducks his skull as if to charge and his legs seem to accelerate till his feet blur.

But after the start of surprise, I immediately recognise the moment. I go so far as to feel a fleeting sympathy. The adrenalin hits the blood even before the attack has been sprung. I hear the whip! whip! of accelerating tyres above the rush of the air stream as the three Cosimo riders slide by on my right in a blur of silver, Sarpedón, Baris, Arkhangelski.

A move both heroic and empty. They were made fools of by a fiction, the deception of that master of deceivers Azafrán. The three of them waiting nerves on edge for us to go for the break, watching for our every sign, each slight turn of the head, each pressure of the finger on the gear lever; at Patrul's illusion of escape the tension snapped and brute force took over.

16

But Patrul had done nothing. He had merely seemed to act. The Cosimo guys were thirty metres up the road in front of us before they looked back and saw they had been duped. They had meant to go with our break, and instead they had gone on their own. Fighting the wind for nothing. Instead of heroes on their wheels they had two of our domestiques who had come from the shadows and dived down the gutter after them, every ligament straining.

Menaleon tucks in behind us and we three become four as we calmly accelerate in unison. We close with the vain fugitives. Their two Qik escorts, at a bark from Azafrán, exhaust the last of their strength with a spurt onto our wheels, cut the Cosimo contact from the vacuum in our wake, then slightly ease the power, slow, fencing them from our escape. It is a beautifully executed movement that takes only a hand-ful of seconds. And now it is our turn to screw up the power, the power which the Cosimo guys wasted in false anticipation a minute before. They are spent, and we are free.

'We go across to Potocki, boss?' You can never tell with Agaxov whether his apparent dumbness hides a super-complex but unexpressed tactical cunning. I think not. He seems to see the whole of human life in just a few big squares, like ultra low resolution video when they're blanking out the significant face in the news picture.

'Good man, Axo,' I say to him. 'No dramatics, just accelerate quietly and take us to the bottom of the climb.' This man, so immensely strong, but he is also so heavy. – We go across to Potocki, boss? Poor Axo. He can no more go across to Potocki than cows can leap from rock to rock. He can lead us to the foot of the mountain, no more. Then while we take wings he will have to haul himself up like a stone block on a pulley. He will not see Potocki again on this stage.

I get behind Agaxov's bulk, and watch the slow quickening of the rippling limbs. It's like being behind a lycra-covered cart-horse. Every time he gets up to full gallop he drops the chain another cog. Finally I watch him move his finger with repetitive puzzlement on the lever. There are no more cogs to drop. I wonder if he can count. He is on 53/11, an enormous gear, and we are beginning to climb.

'Steady,' I soothe him. Like a horse, he will go on until he falls, unable to raise his head from a pool of slather. But I can see the sudden steepening of the road into the ascent proper two hundred metres ahead. 'Just keep it there, gently gently.'

We hit the ramp. Agaxov falls away like one of the dead to the underworld. I will pat him at supper. Menaleon works at the front for a few minutes, then he too fades. It is just the knight and his squire, Sáenz and little Azafrán.

Now we begin to work on the larger scale. Sáenz is of course the stronger, but in this situation there is no finer man than Patrul Azafrán. It is freely admitted. Sáenz does not give praise lightly. But here in Patrul we have a man, of humble peasant stock OK, but whose intelligence to his vanity is as infinity to zero, who, entirely self taught, understands machines, computers, sponsorships, contracts, even women. And as if this were not enough Patrul is the man to be with on a mountain.

We are committed. We immediately rise to that level which is not quite pain, he and I, but to the edge. Every muscle from ankle to spine, in the abdomen, the chest, the arms and shoulders is registering a warning that the edge is close, that the abyss of physical collapse — albeit temporary, overwhelming — is about to call us down. Just as it should be. The edge is where we must be riding. This rhythm we are sharing, the rhythm of being on the edge, it's almost restful. Each circle of the pedals is something shared, like the oar strokes of the galley slave, and we have to make 4000 circles, 8000 contractions of the muscles, before we reach the pass.

We work for five minutes. We know , Patrul and I, we know Jan's maximum and we know our own. This is almost like a law of nature. Our computers tell us we are going at a steady 27 kph, an astounding speed for this degree of climb. Our bodies tell us that nobody could go faster. There remains another thirty five minutes of climbing. We should be gaining about nine seconds a minute, and come up with a tiring Jan in twenty minutes. Then we either go straight past him or, if he hangs in, we wait until a few hundred metres off the summit and jump him there.

After five minutes Jan's lead should have fallen to two minutes fifteen.

So when our team car draws level and tells us that instead it has built up to three and a half minutes — you feel it in the heart, an unnecessary addition of pain.

Soon the catastrophe is confirmed. Potocki has increased his lead by another thirty seconds.

There are moments of realisation that all is not to be as you had hoped. Not small things. That your comrades laugh at you behind your back. That cancer shadows you. That your woman has long been in love with another man.

These things make the heart hurt. Physically. It is therefore more catastrophic when such a moment hits you as your heart is labouring at its extreme.

The realisation dropped on Sáenz like a small hawk of failure that suddenly blots out the sky. I was, it seemed, no longer about to join the four greatest bike riders in history. Victory in my fifth Tour de France was being stolen from me by a man who was ascending about ten seconds a minute faster than it was possible for any human being to climb.

And it was then that a sort of panic seized me. One that was to lie below the heart for the rest of time; now sleeping fitfully, now whimpering piteously in its burrow. There, always. There, sitting on the bicycle, my limbs began to shake. And at the self same moment as despair hit me Patrul, he too seemed to lose his head. Without any warning of mental instability he suddenly sat up and he yelled the most undeserved obscenities. 'Go, go go you fat ponce, piss off you Turk's whore, you prancing fairy, get off your fat arse and join in the race, you pig's pizzle, you rat's rectum, you . . .'

By the time I had pulled a hundred metres ahead and out of range of Azafrán's unjust insults I had regained control. I was climbing on the drops, up one of the steepest cols, at a speed most people could not achieve on the flat. I was going so fast that the wind was rippling over the shoulders of the maillot jaune, the race leader's jersey. Nobody could withstand the force of Sáenz's attack.

Five minutes later the team car relayed that I was still three minutes twenty seven behind Potocki.

Beneath the power, the beast's whimpers shook my frame.

It wasn't just that Jan was having a good day. When you have been racing for a long time you recognise that phenomenon — somebody suddenly finds an unaccountable strength in their legs, and wins a stage by an incredible twenty minutes. It is their day of transfiguration. The next they come 145th.

Something more permanent had happened to Jan. Without there being any apparent reason for it, he had ceased to be the second best.

He had suddenly become — I was not being defeatist to feel this —
unbeatable. It was a fact against nature.

<center>★</center>

Hey, that man Sáenz, sometimes he entertain a certain opinion you might say about the place he take up in the world. But it is, you might say, not so unjustified. No way he gave up, and of course he won the Tour that year. By Paris he was the winner of five *Grandes Boucles*. He had equalled the best. He was secure now in his position at the head of the Pantheon of the great, of Coppi, Anquetil, Merckx, Hinault, Indurain. Next year he would vault up on their shoulders, no problem.

What went on in Potocki's head before it went vacant for good, that is not so clear. Jan, to be honest even at his best he was a descender like Arnold Schwarzenegger is a ballet dancer, and the last few months his clumsiness had increased, making with the brakes too much or not at all, lurching, running out of road, he was lucky that his bones were still attached at the joints and whole.

Sáenz made up two minutes on him in the snaking plunge. Then came the final few kilometres, a broad road into the village, well surfaced and with gentle curves through big trees that came right to the edge. The gradient was now less extreme, but Akil was still doing about 65 kilometres per hour when he passed Jan looking at a sign post.

Azafrán, who had made a truly brilliant descent, passed not long after. I tell you, it is frozen into the mind. It was one totally bizarre scene, so bizarre that one could nearly hit the brakes oneself. Jan, who moments before'd had the Tour de France in his hand, was off the bike, holding it in front of him, gazing up at this little signpost pointing up a track into the forest. His team car was stopped beside him, and Mikkel Fleischman was talking to him, one arm on the shoulder, the other hand pointing down the road to the finish. It was only an impression, but despite the madness of the situation, the impression was that Fleischman wasn't shouting as any normal team manager might do when his best rider has just thrown away the richest race in the world. He was talking to

Jan calmly, like he was trying to talk a valuable racehorse out of a burning stable, something like that.

The grotesquerie was past in a couple of seconds, so to take in the reality, that was something that only came after. But Akil Sáenz had won. Azafrán crossed the line less than a minute after him, a minute twenty seconds up on Sarpedón. Jan Potocki, who by his imperfect challenge had now assured Sáenz of victory, never completed the stage. The uneasy riders at the finish saw the helicopter rise over the trees and head on down the valley.

Apparently he lost his way. He couldn't be quite sure, he said, where he was supposed to be going, and when he saw this signpost, he thought he'd better check.

Jan would've been doing close on seventy kph when this thought wavered across his mind. They said you could see the skid marks. He came back, got off the bike, and stared at the signpost. It was hand painted. They say it was for an *hameau*, Le Goguenard, three chickens and a goat up a narrow stony track.

Leaders have lost their way before – Robert Millar followed the cars into the slip road at the top of Alpe d'Huez one time and sacrificed the stage – but these are maddening split second errors. Jan, you could only say he had lost his way in a much deeper sense. 'I just thought it better to check, rather than to be in error,' he had said, 'and then I couldn't recall the name of my destination. I may have become a little confused.'

Fleischman unconfused him sufficiently to get him on his bike and down the road, though with no chance of catching the leaders. It must have taken a minute or two, because Menaleon was up with him, saw his crash, in fact nearly came down with him. He says he was on Jan's wheel, they were going very fast indeed now Jan was more sure of his destination, and this big frog was hopping out from among the spectators across their line on the apex of the bend.

A professional bike rider, even when he is laid right over on a fast curve, is secure in his reactions. The road is not wet, there is no gravel. You deflect by a few millimetres, you miss the obstacle – or if it is something soft you go over it. A frog is

slippery, it will roll skin to skin, but only for a fraction of a second, you calculate not enough to cause a skid.

Apparently Potocki reacted to that frog as if it were a boulder or a cow or a phantasm in the road. He flipped up, lost his line, went straight out across the bend and hit an oak tree like Superman with his bike still clipped to his feet. He was not killed, but what was left of his mind seems to have carried on into the tree when his skull stopped against his helmet. That's what some of the guys say about helmets. Better to let the job be done properly.

Stage 3

You can imagine the village of Venta Quemada – its stony street, its dust, its low burnt-orange tiled houses.

Ernesto Sarpedón should not have been there to die at all. After the Tour de France come the big city centre races, the criteriums. They are as much fiestas as bike races. Round and round they go, the sigh of air, the ringing tyres, the soft silver burr of dry chains swirling over titanium cogs, they sound like a throng of night insects. In the streets people eat and drink, lose themselves in embraces or confessions, then turn back to cheer the local hero and see the talent of the world, the *coureurs* and *grimpeurs*, the explosive sprinters pass before your eyes time after time as daylight fades and the golden lamps come up.

There is big appearance money for the *campionissimi* in criteriums, and that is why the number one should lead his team to the races. Sarpedón's team didn't have that financial reward, because their leader could not support the glory.

It was the year after Jan Potocki's death by frog. Akil Sáenz had had a terrible season and it was Ernesto who in five months had won four spring classics, five minor stage races, the Tours of Italy and France, and looked to be destined to win the World Championship as well. The whimpering creature of panic in Akil's belly was seldom quiet.

But Ernesto's spirit could not take the load. He became like a child – that Sarpedón who before had been the devil of the pack. The Sarpedón of old, you didn't want to be near him on the road – gob, fart, insult your mother, you despised him but you were frightened of what he'd do next. So how come at the end like they said his behaviour was simple and saintly. His last Tour de France, in the mornings when the riders assembled at the start he'd suddenly drop his bike and go over to some unknown domestique. His big stubbly snout would fall open in a broken toothed smile, and he would greet the flabbergasted rider – not by name, but

like they were brothers who had been reunited after a long war, perhaps, and he would embrace him, and sometimes he would weep. You can imagine what that would do to a young rider. Flattered? Deeply shamed? Confused was not the word.

Ernesto didn't care. He didn't know how people felt. He would finish his embrace and walk off with his right hand at a funny angle, as if about to shake hands, but the elbow back and a little out from the body, perhaps like he was going to raise his arm and bless the crowd. And he'd be muttering gently to himself. Often a Cosimo mechanic would have to take him by this arm and lead him to his bike, which another team worker would have picked up and checked where it had been carelessly dumped. They would make sure his miniature radio was working, and that he had the earpiece in place, help him astride the machine – his earthbound movements had become quite clumsy, like an old video game – and the roll out could begin.

But once Sarpedón was in the saddle and pointed in the right direction there was no stopping him. He seemed to have only one natural speed, flat out, and his team manager had to keep whispering over the radio, like a hypnotist or someone training a horse, 'Cool it Ernesto, drop the pace, easy, boy, easy' so that the guy didn't burst his own heart.

And then there was Paris. It is a tradition in the Tour de France that the overall winner lets a lesser man win the final stage. When Sarpedón came onto the Elysée that year, he went to the front for the first circuit – fair enough, but then the Race Leader should fade from the limelight, tuck himself safely up in the bunch, let the ordinary guys have their moment of glory. He owes it to them. There would be no race to win without them.

Did Ernesto lay off the pace? Did he fuck. He hit a speed nobody could possibly contend with. The bunch began to thin out, to elongate, riders began to drop off the back in droves, and Ernesto still charged as if he was on a lone break-away in the first week of the race. Soon he was on his own, there was a hundred metre gap between him and the next

group of three, who were now sitting up, puzzled, waiting to regroup.

This man already had all three jerseys, the Maillot Jaune, the green points jersey and the King of the Mountains. What did he want, to be taken up into heaven? It was an embarrassment. Sarpedón was like nothing so much as an electric hare on a greyhound track, regular as machinery, unstoppable. '*Décroche le robot*,' the huge crowd was shouting, half in fun, increasingly in anger.

And then it was seen for Sarpedón to put his hand to his radio ear-piece, shake his head, sit up, and come to rest with his hand on the barrier.

The roaring crowd fell silent. The breeze in the trees, distant traffic were heard. *Aficionados* felt a cold grip in the entrails. They remembered the story of Jan Potocki, looking at the signpost. But soon came the singing of the tyres, the whir of a hundred and twenty chains. The blaring colours of the peloton swept past the little lone figure on the barriers

Ernesto raised a hand and smiled gently, as if to acknowledge a group of distant acquaintances passing on a country road; then he suddenly looked worried, put his hand to his ear-piece once more, and took off in pursuit. But the unvanquishability had gone. He finished towards the back of the main group, in an empty space of his own because he seemed unaware of the riders around him, and was swooping from side to side like a boy on a bike on his way home from school. On the podium Akil, who was second overall, and deeply exhausted in trying to keep up with Sarpedón in all sections, also Ettore Baris who was third, had to join the girls in helping Ernesto through the routine, the jersey, the champagne, the flowers, the waving. He made the gestures, manipulated like a puppet. His grin was not of victory but of incomprehension. He had the eyes of a frightened kid on his first day at school.

There are always people who shed tears at moments of emotion, and who's denying that the presentation on the Elysée is one of the great occasions of sport. But as one looked round at those tough men who minutes before had hated

Ernesto; who now felt, without a shred of historical evidence, that he had once been a true compañero; their tears, they had a bitterness as they ran through the dried sweat onto the tongue; wormwood.

So it can be clearly understood how Ernesto Sarpedón, Tour winner, campionissimo, could not lead his team to reap the money and publicity rewards on the criterium circuit.

Why, in the little out of the way village where he returned to recuperate his spirit, he should have been put violently to death, is not so clear.

<p style="text-align:center">*</p>

Gabriela Gomelez's high heels made a city noise on the stony main street of Venta Quemada. Street! It was more like Rattlesnake Gulch, though bright enough in the morning sun. Gabriela's high heels were smart chick; elegant, tan leather, expensive.

Gabriela was an up-to-the-minute woman and she had a point to prove. Who can say why when she'd graduated first by several per cent from the police college in Avila she wasn't snapped up by the top cops in Madrid. Surely nothing to do with as yet imperfectly reformed gender attitudes in the forces of law and order. Whatever, instead of forensic glamour in the capital she was posted to the small town where the E25 crosses the Guadalquivir between Bailén and Córdoba.

She left her two uniform guys to wander and went straight to the venta itself. It smelt strong, not unpleasantly – coffee, wine, cigarette smoke and curing ham, sure, but leather? tar? figs? distant pigshit and patchouli? Gabriela paused for a few seconds, silhouetted against the hot reflections of stone and clay, breathing the relative cool. Once her eyes had adapted, she made out three men of that age peasants reach after their youth has gone. They greeted her formally and shouted, and a youngster came through a small door and leaned on the counter.

Gabriela ordered an espresso, then went and sat where she could see the whole bar. She took cigarettes from her leather shoulder bag, struck flame from her lighter in mid draw and,

blowing out a grey plume, let her eyes travel, inviting conversation. She had already added to the bouquet of the room, obvious to any new arrival, the insistence of her perfume. Lipstick, freshly applied as they had drawn into the village, scarcely glossed the filter of her long smoke

'Are they just travelling through, the cops?' asked one of the men.

'You know we have business here.'

'And what is she to the cops, this young woman?'

'I am their boss.'

'We are aware of progress,' said another. 'Women. Bosses. We live here, but we understand such things. Why, our own granddaughters drive flash cars and refer to copulation by its first name. We are not bitter at your authority.' The man glared at her, then suddenly smiled a friendly, toothless smile. She smiled back quick and short with her eyes.

She just had to sit there and they would come to her. Over the next hour and without the detective lifting a finger the venta transformed itself into a native court. The uniform guys stood beyond the door, keeping a relaxed watch on the children, dogs and a pig which were not much encouraged to join the formal proceedings.

There was even a president. She too was a woman, though with many more kilograms, chins and years than Gabriela, and a rough, growling voice in which she called the company to order. She introduced herself to the detective as Señora Emilia and went on:

'Señora policeperson. A week ago a son of this village returned to his aunt and uncle there.' The couple stood momentarily and bowed to Gabriela, who raised a hand in greeting. 'I say a son of this village, but that is hardly so. His parents came from here, but both are long dead.'

'God rest their souls and have mercy on their sins.' The sincere reflex went round the bar like the last whisper of a storm, for only the ancient spoke, while the young winced with embarrassment at such old-fashionedness before the sophisticated stranger who stank of perfume.

'. . . on their sins,' Sra. Emilia corroborated. 'Ernesto took

an apprenticeship in Segovia, and we have not seen him again until his untimely arrival here, by which time he was mad, simple, and appeared to have been sent here, out of the way, so as not to cause embarrassment in the wider world. We do not know who brought him. 'They are dear friends,' he said, though he clearly had no idea who, rude men in a Mercedes who did not stop but left him standing in the street there with his bags in his hand and his mouth hanging open. His aunt and uncle recognised him from the newspapers, and took him in, grieving at his condition. Why?' the old woman's voice suddenly raised an octave, 'why did his friends, his employers not care for him? Why did they throw him out at the peak of his fame, just because he had become an idiot?'

'We're keen to find out,' agreed Gabriela.

'And you will then come to explain to us, to us *simple* people here?'

'I note your irony,' said Gabriela. 'We can work together on an equal footing.'

But they did not work together. She'd already had a feeling that this finely articulated sense of injured innocence was just a preface to some crass bollocks got up to deflect suspicion. For quite what bollocks she wasn't prepared.

It started in a deep rumble from Sra. Emilia, and went like this.

'At the mouth of the steep sided valley there, in the foothills of the Sierra Morena, the ravine you drove your big car through to reach us,' she pointed to the south, 'at the mouth was an ancient gallows in an enclosure. The oldest amongst us can remember the gallows tree before it fell, with shreds of sun-tanned skin still about it, and the stink of carrion flesh. The last to hang from that gallows were the Zoto brothers three.'

'When was this?' asked Gabriela.

'In times gone by,' said the huge old woman, with a glare that suggested that if she wanted mere cheap accuracy she could go elsewhere for the account. Gabriela bowed her head and noted, 'In times gone by'.

'Very well. Now it is known, and it is easy to believe, that

the souls of the hanged are not tranquil spirits. It is not at all surprising that the Zoto brothers after their bodies' death remained in the region, taking on various horrific, blood-chilling forms and leading people to perdition. That is not surprising, would you say?' She looked enquiringly at Gabriela.

'It is a view that many hold.'

'I see. Many idiots, perhaps. Many uneducated peasants. Many of the kind of people you see around you.'

Gabriela threw up her hands and smiled disarmingly. 'Who am I to say. Personally I do not believe it.'

'Me neither,' said the old woman. 'Nevertheless, we must have respect for those who do, superstitious nonsense though it may be. The fact remains that three days ago three characters came down from the Sierra. Like the Zotos they were armed in twenty whichways, with pistols, carbines, shot guns, bandoleers with many different kinds of bullets, daggers, a sword each. They were a joke. And they stank. Personally I have never smelled a hanged corpse that has been on the gallows a week or so, but that is how I would imagine the unbearable stench of such a thing. It was like – as if you kill a pig and do not butcher it but leave it there for a month, and then these machistas roll in the pullulating remains.'

'But here when you kill a pig you butcher it at once.'

Sra. Emilia glared at her. 'Listen,' she said, 'I know what you think. You think that one or more people here, or perhaps not here but known to us, killed Ernesto Sarpedón and butchered him like a pig. You think the person or persons did it for some motive. All you have to do is to find the motive, and you will have the person or persons wriggling on a pin. Now, I am telling you what actually happened. If I were you, I should listen. These three bandits came down from the Sierra armed to the teeth three days ago. They made certain demands, which as you can imagine were disgusting, reactionary, and not to be countenanced. Predictably, the hymens of the three most nubile virgins in the village were foregrounded with an almost gynaecological focus. Well, we needn't go into that.'

'The school teacher, perhaps . . . ?' enquired Gabriela, more and more puzzled by Sra. Emilia's delivery. The old woman gestured to an unfortunate in the doldrums of life, who gave a hunched half wave and dropped her head almost to her lap. 'If you wish you could question her about her virtue. As to nubility . . .'

It was excruciating. 'I meant . . .' now Gabriela had to explain. 'I meant you – words like *foregrounded, reactionary* . . . how do you, Sra. Emilia . . . ?'

The Señora's gaze allowed a perfect pause to form, then just before cruelty set in she took the attention back to herself. 'We told the bandits in no uncertain terms that their attentions were not welcome, and they could bugger off. Cursing and grumbling they did so, but not without making it clear that we should be punished. Well, of course, we made sure that the flower of our womanhood was protected – such as it is – no huge task. But how were we to guess what was their true target?

'What followed, you know. Ernesto had been quartered in a room hard by his aunt's and uncle's house – a room not long ago, it has to be acknowledged, a stable, but now clean and dry, with a bed and chair and table. He had his meals with his relatives, but it was felt the man needed time on his own, to sit, and stare, as he did, and not be worried by chatter which he could not seem to understand.

'Early this morning the body of the poor man was found laid out on the plain scrubbed table his aunt and uncle had put in that hovel for his convenience, now thoughtfully covered with a polythene sheet. The unfortunate's torso served as the centre for the display, with the limbs neatly arranged around, and the head balanced on the chest. All this you know. You will ask me, did anybody have a grudge against Ernesto. As far as is known, no. You will ask me whether anybody stood to gain by his death. He was a rich man, it is true, and had no wife. None here has seen his will, but it is certain that none here will make a penny from this tragedy, nor, I would swear it, would any here kill in such a way for such a motive. You will ask whether we heard nothing. As you know, the

Sarpedón cottage is at the end of the village, and that night a loud dry wind blew from the north. Doors may have clattered, perhaps the odd cur growled at the creak of hinges. Perhaps at odd times in the night a man may have gone to his door and peered into the pitch-black street, mindful of the bandits' threat. But nobody saw anything at all out of the ordinary – which as I say, when you consider the location of the room where the doomed idiot slept and died, is not surprising. That is all we can tell you.'

'It's very neat,' said Gabriela.

'Not at all,' snapped the old woman. 'A man dependent on our hospitality has been brutally murdered, and we can be of no help in bringing his killers to book. I don't call that neat.'

She stared Gabriela down, and when the detective looked up again, Sra. Emilia was chuckling. 'Little baggage,' she said, 'of course we know what you mean. It is your duty to assume that we are making up this highly unlikely story in order to cover up – oh, satanic rites, an old blood feud that goes back to before the time of Christ, some misguided belief about wealth and inheritance. Of course we might be covering up for each other and ourselves. But as it happens we're not, and it would save you a lot of time if you believed me, and started searching for the Zoto brothers. It seems to me obvious that whatever chain of events brought the tragic Ernesto here, might have a parallel in these implausible bandits. However, it's not for me to teach you your business.'

'Thank you for understanding.' Gabriela smiled round, and the nods and smiles she got in return did not seem anything but shy and friendly. 'Just one more thing. Have you any idea what happened to the missing organ?'

'We too were surprised by the lack of blood.'

'Anything else?'

Sra. Emilia looked round enquiringly. 'The masculinity was there,' said one of the old men, 'modestly packaged in the enormous heart.' There seemed nothing else to add, so Gabriela added it.

'There was no trace of Ernesto Sarpedón's brain.' She left a long dramatic pause. 'The cavity of his skull had been sluiced

out with a powerful pump and solvent so that not a cell of the seat of consciousness remained.'

'A technology rather beyond us, I'm afraid.' Sra. Emilia sounded almost apologetic.

Apart from having the names of three probably never living, certainly long dead bandits, Gabriela was no closer to discovering who it was that had cared so much for Ernesto Sarpedón's well-being that they had spirited him away from the intolerable pressures of professional cycling to the tranquillity of the countryside, which helps to heal all mental wounds.

Stage 4

Akil Sáenz always had his wife with him on the big stage races. It was really necessary to the balance of his mind. Not just the primary sex, one would guess; only a lover can give the constant emotional nutrition — praise, sympathy, more praise, more sympathy — that Akil needed. Or, probably more the case, only a deep lover could put up with the blame for not delivering quite the absolute quantity, the perfect quality of worship that greatness requires.

Akil's woman was called Perlita de Zubia. If you ever saw that film about the Chilean poet Pablo Neruda and the postman, Perlita is like the postman's woman when she takes her blouse off in the empty cinema, so round and firm it gives you a feeling in the pit of the belly like holiness. If you missed that movie (the Spanish original, not the Italian copy), may I make a suggestion; see it, it is the best thing ever made. And then also you will have some idea of Perlita. She devoted seven years of her life to Akil. One hears a bit, and discretion is a duty where there are no other overriding considerations. To listen to a woman's secret thoughts is something you must pretend has never happened, and to repeat them is worse than stamping on your mother's grave — and all that stuff. However, I have good reason for this which may in time become clear, but what my authority is, that stays with me. So here, unexplained, is something that will describe the relationship between Perlita and Akil.

Perlita

I remember a boy did this once, when we were very young. It was a warm autumn day and we had gone to a field on the hillside to make love. We lay just in the shadow of the tree tops away at the bottom of the field, and there were crocuses everywhere. Soon the old women would be coming to pick them for the saffron harvest.

We were both very hot for it, the boy and me, and then suddenly he lies on his back and makes soothing noises, calming me, like I was a young mare, and his thing goes small and soft, and I think, 'What the hell?' and then when the end has disappeared he picks a crocus, a yellow crocus, and puts it upside down like a little cap over the stalk of his foreskin, and he is laughing now, quietly, and I think, well this is his game, but I need him big inside me not playing with flowers, and then he holds his cock in his hand, and by magic it gently swells, and the skin stretches open and the purple head slides out, and so smooth and gentle is everything that the crocus stays on the end as it grows, covering the eye like a yellow nipple on a little purple breast. Then slowly his smile tightens into a grin and the crocus shoots in the air on the sudden fountain of the first long spurt. And when it is over he is still laughing.

But it is not funny and I smack the boy on the chest with both hands, smack, smack, smack, and he goes on laughing. 'That's no good to me,' I shout, and I kneel up and point to myself. 'What's that for, do you think?' I point at his lolling thing, dribbling on his stomach. 'And what's that for? I needed that. In there. Maricón.'

I can see his thing begin to swell again, but instead he takes the dripping crocus flower, and puts it on his finger and very gently, almost tickling, makes my happiness with that. I collapse across him covering him with my breasts. But I am still angry inside, where nothing big has happened.

'Perlita,' he whispers in my ear. 'Perlita, I can see the old women at the top of the field come to pick the crocuses. We've had many good times, Perlita, you and I, but when you are an old lady in a black dress come to harvest the saffron, this will be the one you remember.'

He was wrong. I am Perlita de Zubia. I shall never be an old lady in a black dress. I buy my clothes in Madrid, Paris, Milano, and they are not suitable for harvesting mountainsides in the distant West of saffron or wheat, or for hoeing and weeding, or making cheese, or gutting fowl. But he was right, that boy who left to be a racing cyclist and who I followed — no, not Akil Sáenz, just a peasant boy who made good with his great stamina and his tactical skill. I do remember you very close.

That is what they mean, I think, sex is a laugh. It is a very deep laugh. They talk about a belly laugh. Sex is a laugh below the belly.

What is laughing? Do we just say ha ha ha? No, in deep laughter we hold the breath so that each pushes down, right down to below the belly, and let it go, and hold it again, and let it go. It is something like coming, deep laughter.

But with Akil sex is never a laugh. Oh it is good all right. You could say it is magnificent. We can scale high summits, with all the physical duress and triumph, the long hurtling descent. But there are no crocuses in Akil's love, it is not studded with gentle unexpectednesses. What, I wonder, will be my last memories of passion, when I am a very old old lady, when summits are things on the distant horizon, but there are still flowers at my feet?

I hope I am forgiven for sharing this confidence. It does not seem to me that it reflects badly on anyone.

Stage 5

Gabriela

'But why don't you ask the anthropologist?' the goatherd said.

I am standing on what seems to be an ancient roadway up in the Sierra Morena. Its huge paving slabs are half buried in fine red quartz. My Landrover Defender is parked by a broad well with a low stone wall around it. Tadpoles with little legs either side of their tails are coming to the surface to breathe. Their bodies are huge, the size of pullet eggs, and a light muddy green. Their eyes meet yours as their open lips dent the surface.

There is nowhere here that a frog could possibly survive. I assume that these tadpoles are an adaptation, and their entire lives are lived out in this well – unless there are deep subterranean connections to other places.

When I stopped the vehicle to see what the circle of low stone was, the white noise of the wind drowned out the hiss of the radio, and brought the soft clank of goat bells from an old olive grove a few hundred metres away. Soon the goatherd, a man perhaps in his seventies, came over with his dog to greet me. When I had enquired after his health and the health of his flock, I brought the questioning round to the Zoto brothers, and he had made his suggestion.

This was something new. *'What anthropologist?'*

'The one that came in the helicopter.'

'Helicopter?'

'A craft like an aeroplane, but it has a propeller instead of wings. Or, put another way, the wing sits atop the machine on a sort of hub, like a cartwheel, and spins around. At the tail there is another propeller, facing sideways, to counteract the motion of the first. A helicopter does not need a long roadway to land on, for it . . .'

'No no, I know what a helicopter is. But who was the anthropologist?'

'He was an anthropologist. He wished to be known by his profession. That's fine by me. He was little interested in goats – old stories, principally, were his care, I guess.'

37

'Did he come alone?'

'Oh yes.'

'Was he Spanish?'

'He was not from these parts, but then,' the old man looked around the grandeur of the uninhabited mountains, 'few are. I understood the words he said.'

'And he asked about the old stories of the hills.'

'Precisely.'

'And you told him the story of the brothers Zoto.'

'Among many others.'

'But that one particularly. How does it go?'

We walked across the red quartzy sand to the olive grove and in the shade of the old grey trees, the click of light in their branches, against the occasional sound of the lead goat's bell, the stink of goat on the hot wind, and the quiet buzz of flies around the sleeping dog, he told me the story of the brothers Zoto and the Venta Quemada.

When I was getting back into the Land Rover I asked him if he could remember the registration number of the helicopter.

'All the writing was taped over,' he said. 'I thought that was unusual for an anthropologist.'

'Do many come this way?'

'I meant as against a criminal, or a spy,' he said, smiling gently. 'However, the writing that warned against dealing rashly with the innards of the helicopter, that was not in the language of the golden tongued de Vega, nor again of the tempestuous Shakespeare.'

'Was it not?'

'No, that minatory text was in the tongue of the incomparable Boccaccio.'

So, an Eyetie whirlybird. These goatherds, eh?

*

Sarpedón's death. The brainless remains have been assayed every which way – no trace of any drug, no trace of any anomaly whatsoever. But then who is looking for simple substances these days.

At the moment I am working on three hypotheses.

One: The villagers did it, then extracted the brains by some means which smacks of painstaking laboratory practice. Perhaps they used the retrieved matter for some odd rite. At any rate they

disposed of it effectively. A highly technical search has found no trace . . .

Two: Three bandit brothers, long dead, came down from the mountains, demanding maidenheads, were rebutted, and in vengeance and the middle of the night, slit Sarpedón's throat and carved him into joints, taking his brains along with them when they left – for some reason. If not actual dead bandits, then . . .

Three: Person or persons, acting on behalf of Cosimo Pharmaceuticals (?), mounted an elaborate masquerade in order to get rid of a brilliant rider who had become an embarrassment. They took care that Sarpedón's missing parts did not become available to public scrutiny, because . . .

So, no conclusions yet.

Meanwhile I have had a check run on all helicopter movements in the relevant period. It's so simple. A Señor Carvellho hired a Supermaggio P-45 from Cab-Air at Barajas. Easy. He's our anthropologist. All his papers were in tip-top order.

I checked out Señor Carvellho. A real person, it seems. A Portuguese revolutionary and guerrilla in the sixties and seventies, instrumental in the overthrow of the dictator Salazar. To survey terrain, Carvellho used to pose as an archaeologist looking for prehistoric sites. In his cunning disguise of a long grey beard and outrageous hat he would hitch rides on military surveillance planes.

However, while the concept of such warfare was born right here in this sierra, what interest can this exemplary guerrillero have in prosecuting it against an innocent racing cyclist?

And Cab-Air; the airway of cabreros, goatherds. Obviously our anthropologist has a sense of humour – so engaging in a murderer.

Stage 6

Mikkel Fleischman, Cosimo team manager and doctor, confirmed to Europol that it had been Sarpedón's own wish – he had pleaded, tears rolling down his face – to return to the village of his forefathers after his victory in the Tour de France. Waiving all contractual rights, Fleischman himself had paid a couple of guys from a bona fide high street security firm to drive Ernesto from Paris to Andalucia, because he felt the sick man would not be able to stand the pressure of public eyes on a plane or a train.

In bike racing, it is unusual for the team doctor and directeur sportif to be the same person. Their roles are so different. The guy who manages the competitive side is typically an ex-cycling pro in his thirties or forties. A team doctor on the other hand will be a highly educated man, a specialist in sports science. The brighter his reputation, the deeper the shadow behind it. A sports doctor to be any good, he has to alter your body, put things in, take stuff out. Francesco Moser, weeks before he broke the hour record they sucked blood from his veins, separated out the red cells and froze them in glycerol, then at the last moment melted them and squirted them back into the living bloodstream. Legitimate, maybe, but it's close to vampirism for an honourable profession.

*

'Tell me about Mikkel Fleischman.'

Akil's house is designed by a Macedonian architect, he says. Outside, wood and stone, it doesn't look much, but inside according to the Vogue feature it's as truly tasteful as holy shit. The top floor is all living room and looks beneath deep eaves across the valley – vineyards, meadows, orchards – to rocky oak and chestnut covered hills. Within, the decor is wood, expensive wool, ivory. Where there's metal, the inlay on the hi-fi plinth for instance, there's no messing. It's gold. The blue is lapis lazuli. Perlita, she has real taste, and knows the right

designers. Peasants have the reputation to make big fashion mistakes when they hit the money. Not Perlita.

The three of them are drinking Oolong tea. It's a great de-oxidant. The third is Gabriela Gomelez, the cop from Andujar in the Deep South where Sarpedón was butchered.

De Zubia isn't half cute, she notes. Tits to die for. And watchful. She turns to Perlita, not just her head, her knees as well.

'What do you make of Mikkel Fleischman?'

'After these cyclists, whoof, he's a very attractive guy.'

Gabriela looks from Perlita to Akil, screwing up her fore-head and raising one eyebrow, smiling at the same time. Then back to Perlita again. 'Of course.'

'It's true.' Perlita sighs. 'These guys,' waving a hand, disparaging smile, at Akil, 'they burn raw glycogen like a blowtorch. Fleischman, you can see a still blue flame in there. Intelligence. It's what a girl wants once in a while.'

'The brain is a very hungry organ.' Akil growls as part of the act, but he's not feeling threatened. 'Did you know that people with insufficient appetites, thin thin people, they suffer a significant intelligence deficit. Not that you,' blinking slow-ly at the policewoman, slightly out of phase so that the purple glow seems to shimmy from eye to eye, 'are anything but healthily slender.'

Gabriela ignores the flirtation and goes along with the ser-ious bit. 'Health. It's not any more just a matter of keeping clear of recognisable illness. It's now more a philosophical question, perhaps.'

Perlita is irritated by the élitism. 'Nothing's ever simple. Even in a peasant village, you can be ill without having the 'flu. There's depression, phobia, madness, witchcraft – all these can happen to a person without your having to be a millionaire.'

'Of course,' Gabriela knows Perlita's background, born and raised halfway up a mountain in the back of beyond. 'I didn't mean that. What I meant was that there didn't used to be the choice.'

Perlita shrugs irritably. 'But nobody chooses to be ill.'

'Oh no?' almost contemptuous. 'Well I read in Nature that . . .'

'For nudists?' enquires Akil.

, 'No that's the other one – for big pricks. I read in the scientific journals modern training demands such high levels of output that it just basically fucks the body up for good and all. The general sensation during the racing season is one of exhaustion. The usual appetites are diminished or absent. Worst of all, the immune system is heavily suppressed. Top riders are as vulnerable to infection as those flyblown babies they have in the third world.'

Akil shakes his head, pityingly. 'We eat, we sleep, we screw. I think that's what we do, isn't it?' Perlita flutters her eyelids, mock-girly. He goes on. 'The immune-response deficiency, that's true, but it's at its worst for twenty minutes after very extended effort. You just gotta be a little bit careful. You don't want to get it muddled up with SIDA.'

'Muddle isn't a thing I go in for. Let me, if I may, ask you a question. How much is it worth to win?'

'Ask my accountant,' says Akil. 'I pay him not to tell people.'

'No, I mean the other thing.' Akil just frowns slightly, not understanding. Gabriela puts her head on one side. 'Has Mikkel Fleischman ever made approaches to you?'

'Is he that sort of a boy?' It's disingenuous. He knows the answer.

'Let's keep it simple. Now, you guys, you make sacrifices. I've been reading the journals. Training, it's not like the Greeks, is it, just making the body muscular and beautiful. I've heard ex-athletes talking on telly – the ones who are ready to admit it. They say things like, "It depends what you want. Do you want, like I want to be the best I can. Or do you want to be – the best. If you want to be the best . . ." and then they shrug. You're one of the top professional athletes in the world, Akil. What does that shrug mean?'

'It means . . .' Akil shrugs. Then he sits back and stretches his long legs. He has soft pale jeans, expensively distressed and every few threads of the warp are dyed the colour of his eyes.

He has white wool socks, rather loose, falling away and emphasising the dark slenderness of his ankles.

'Come on Akil, this is a murder investigation, not one chap interviewing another chap for a cycling mag. I'm an outsider. A shrug means, "Y'know." What do y'know, Akil?'

Now it's Akil who looks contemptuous. He could make the crocus glow go like slate. 'Come on, baby. You'll have done your research. You'll have chapter and verse on every damned substance that's available in every backstreet gym from Burgos to LA. What you asking me for?'

'OK, simple question. Is it possible to be the number one cyclist in the world without taking banned substances?'

Akil points to his chest with his whole hand. 'Of course.'

'No. I don't mean to be offensive, but I said number one. You know – the best. That was the point the athletes on telly were making. When they shrug, when they say with that shrug, OK, so I do drugs to be the best, surely Señor Sáenz that is the distinction they are making. Anybody can feel smug and be the second best. The best, that's what we're talking about.'

Akil stared at her a long time. 'I don't suppose it's occurred to you,' he started quietly, 'that if you are naturally the best, if you are exceptional, close enough to being unique, then doping, or whatever it is they do these days, that's a bit of a downside for the sport. I don't suppose it's occurred to you the kind of position it puts someone like me in.' Gabriela tries to interrupt him, to assure him that she understands exactly the position it puts him in, but he just ploughs on. 'I want to be the best, I am the best, and then some fuck by the name of Ernesto Sarpedón begins to pump something into his system that makes him better than me. Well, Sarpedón's system, I couldn't give a toss for that, but what it's saying is, Akil Sáenz, if you're ever going to win again, if you are ever going to become the greatest ever like destiny promised you, then you are gonna put the same shit into your body that Ernesto is pumping into his. So, I don't know whether this occurred to you, but what I then do is, I put a contract on Ernesto Sarpedón and I hire this thug to go down to Andalucia and

cut him up into quite small pieces. I don't know if that occurred to you?'

'Of course,' said Gabriela. 'I'm a professional investigator.'

'And you have proof.'

'No – no of course I don't have proof.'

'Then what you going to do?'

Gabriela opened her hands and shrugged. 'Precisely as I am doing now.'

'Aha. An arrest is nonetheless to be effected?'

Gabriela shook her head pityingly. 'I said it had occurred to me. I didn't say I gave it much thought.'

'Well think about it now, Señora Gomelez. It is not a trivial matter. A fuck takes from me my birthright. He does it in a manner that is underhand, sneaky, despicable, and which I can't do a thing about. Am I not justified in having him put down like a worthless beast? Is it not my right? Would I not be in turn despicable if I did not have the offal disposed of?'

'Well, I'm sorry Akil, it's all very impressive, but as a murderer, I'm sorry, I don't take you seriously at all.'

'But did I not have a right?' He thumped a fist down on one violet clad knee.

'I think we're heading off into displacement activity here. Investigator discusses the ethics of murder with suspect – a philosophical breakthrough! No, Akil, all I'm asking you is something really boring, a professional bike rider's opinion of, you know, out of all this shit you can take, and you're right I have done my homework and I know the names and the doses and the effects, but it doesn't really mean much to me in my heart, in my liver, in my thigh joints, because I don't need it Akil, it wouldn't get me anywhere, so what I am asking is really what you would take, what kind of suffering, long term lethal, short term painful, affect your brain perhaps, your mind, your perception, headaches, cramps, what kind of shit you would shovel into your body in order to regain what you call it, your birthright?'

Akil let her in a bit. 'It's the question, isn't it? It's a question second-rate professionals have to ask all the time. Those poor fucks, the exhausted, the sick, they haven't much time to

think, and not much brain to do it with, a lot of them. If they weren't bike riders, domestiques, they'd be taxi drivers, crack dealers, third division pimps. In that sense, sure, you're right. For the second-rate, being a bike rider is itself something like a drug habit. But people like me, Azafrán, Baris, the top guys, we are looked after and we look after ourselves. Moments of complete exhaustion sure, and after the long stage races you're tired, so very tired that sleep is a problem – but I recover like a baby, that's it, like a baby, just natural to me, and I make sure I have the space to do it. So, when you say, 'winning, what's it worth?' with me it's not a question that arises.' He paused and looked her calmly in the eye. 'I was fooling just then. I'm being tested a bit, sure. Maybe I'm being tested by new stuff, I don't know. Those guys, Potocki, Sarpedón, they are – were – very good riders. How do I know what they shoot up. Perhaps it's nothing. Perhaps they just got lucky and then they got unlucky. I am here and they are not. Whatever it was, they paid. I,' he flared his nostrils slightly and his eyes glowed so that Gabriela, despite herself, felt it as a slight inner whirlpool, 'Me, I can win without having to pay.'

They pass by very quickly, those moments when the gods make us say things which seem to challenge their right to rule.

'And for the dead – was it worth it for them?'

'Worth?' He dropped his head. He thought. 'Suppose they *were* on something, something that did their brains in. Did those guys know their brains were being fucked? Well, you don't, perhaps. You have to be able to think straight to realise that you can't think straight. Terrifying, eh, how near we are to the edge of not knowing anything, let alone who killed my colleagues. The barber who shaved every man in the village who didn't shave himself.'

A reflexive agent in Gabriela's brain wondered for a moment whether he might really know something. 'What? In Venta Quemada? I met no barber – and what do you know of the village?'

He looked vague. 'It's just a paradox.'

Gabriela was laughing. 'Of course – silly when one's mind gets locked onto one thing. Please go on.'

He thought silently for a minute or two. 'If someone came to me and said, "Cosimo Pharmaceuticals has developed this secret undetectable wonder drug. With it you can win all the big races in one season, then we'll bump you off because by that time your brain'll be shot," well, frankly, I can't see it as being a very attractive option. Can you?'

Gabriela shrugged. She had never been in that position.

Stage 7

Mikkel Fleischman was one of those mildly extrovert Swedes who speak English with a perfect Seattle accent, and fluent Emilia-Romagnan Italian. He was of average height, had thick wavy hair, blue eyes and wore gold rimmed glasses. He smiled a lot, but always a degree and seven minutes to the left of where you were.

Sports medicine had not been his first calling. Mikkel was a clever man. His initial degree from Lund University had been in molecular biology. From Lund he had gone to Bologna where he had been an assistant in research into the cerebral damage caused by Gerstmann-Sträussler-Scheinker and iatrogenic Creutzfeldt-Jakob Disease. Italian scientists were leaders in these areas of protein abnormality, and Mikkel was disappointed that his contract had not been renewed, for budgetary reasons. He went to a teaching post at East Garfield University, Seattle.

One night he was at a party at the home of the cardio-pulmonary Professor, Ivar Shinkalanyanaram. Parties were good for business, but in fact Mikkel had gone to this one less to meet the useful people he might meet than because he had seen one of the professor's sons at the Starbucks near the campus. Shinkalanyanaram's wife was a Scot called Flora MacDonald: Mikkel was hardwired for blue eyes and stubble in coffee-coloured skin and he'd been angling all week for a way of making closer contact.

But often you get what you didn't go for. Almost as soon as Mikkel hit the party the son took off with an airhead, air-chest female and signs of a sexual impatience which meant that any casting of significant glances on Mikkel's part was an expense of spirit; indeed, in the absence of the boy, impossible. On the other hand he got talking to a Dr Taggart Lohengrino-Kung, a plastic surgeon in his late twenties who already had his own jet plane.

It seemed what Taggart did went far beyond cosmetics,

ethically and practically. He had made his name in techniques for getting supportive tissue – bone, muscle, fat – to build on minimal biodegradable scaffolding, like they could make a human arm grow on a few strands of stuff in a glass tank that if you found that arm subsequently in a lay-by or a garbage container and you took it to the police station, they would sit you down and they would talk to you seriously and with respect. Some of the things he and his various teams had done for car smash and burn victims had been right at the forefront of this type of body building.

If the word still had any meaning, Lohengrino-Kung was a genius. An attribute necessary to genius is never for a moment to be satisfied. The humanoid parts he cultivated were living, genetically identical to their hosts, and they worked. Not perfectly yet. The hand-arm combinations were better it seemed at beating eggs than making love, but there was no future limit on perfection. Designer humans. Information made flesh. Taggart Lohengrino-Kung was nearly there.

Fleischman worked at the Lohengrino clinic for just over a year. Then the scandal struck. No suggestion that the three young Paraguayans had come there under duress, no suggestion that all immigration procedures had not been complied with to the letter. Arguable that any law had been breached. It did not prevent Taggart from losing his license. However the bread and butter work of the clinic was uncontaminated by the controversy, and he was able sell up and jet away, a very rich young man.

The Paraguayans were shipped back to Paraguay. They didn't understand what the fuss was about. They didn't understand anything much any more. At least they were happy. Wherever you sat them down they smiled.

Kung made it clear to the daylight world that never again would he try to make man in the image of angels.

Mikkel Fleischman went from Seattle back to Bologna to study medicine. He had a reference from Lohengrino-Kung that confirmed he had had no part and no interest in the one shadowy area of the clinic's procedures. A brilliant research career was forecast.

But one weekend a friend rang him at the lab and asked him to stand in for six hours at a sports clinic. Normally he would have gracefully and charmingly refused. He wasn't interested in sport. Also he was a strict self-disciplinarian, like a lot of hard workers who feel that at heart they are lazy, and it was not his habit to interrupt his schedule. On the other hand he had come to one of those natural pauses, he'd finished his housekeeping, he didn't want to start the next phase of the project. He accepted an unusual impulse to for once do something idle and eccentric. The clinic it was.

Oh happy day. Trivially amused by the self-important posers, bankers and businessmen he guessed, who held forth authoritatively on imaginary conditions they hoped might stand in for physical prowess, he felt he was genuinely useful to the aspiring youth – football, basketball, field and track athletes – who were taking an intelligent interest in the operation of their bodies. And then the young Peluso, the angel of Arezzo, came in with a broken leg.

This was before 'Gee-Gee' Giacometti Peluso was a famous name, the greatest climber since Lucien van Impe. The leg had been a clean fracture, caused by riding rather fast into the side of a van while paying too much attention to the bosom of a young woman on the other side of the street. His *directeur sportif* said that for such a crime he deserved castration, and when Peluso recovered he would have it written into his contract that this exact penalty would be the result of the first sign of further carelessness. Gee-Gee, who affected devout Catholicism while being the biggest womaniser in the bunch – slender thighs, like all great climbers, but an extra one for luck, as his team mates wistfully put it around, though the information was hardly necessary given lycra shorts – said that of course he hadn't been looking at the young woman's bosom, he had thought for a moment he heard a voice from above, and naturally looked upwards, and the van had reversed out of an alley in front of him at just that point. There was no truth in this. His lies outnumbered even his fornications.

The clean fracture had been perfectly set. It was just a matter of restoring the muscles to functional symmetry.

Mikkel was at once obsessed. Two things came together like two nuggets of plutonium, and there was a flash, after which nothing was the same.

Stage 8

Patrul, this time as always – it was the day after Gabriela Gomelez had subjected Akil to her subtle interrogation – this time as always Patrul hoped that Perlita would come in the Xantia Estate, not the Diablo. Why the cowardice, he often wondered. What greater pleasure than to die in the company of such a woman? – a mixed splatter over the inside of the windshield of a car so low you could trip over it in the dark, and then as the windshield itself burst forward, a bloody glitter of him and her dashed like hail among the roadside rocks and trees. Romantic! And yet, the fear won out. He did hope it would be the Xantia.

Today was a four hour training session with the heart some few points below the aerobic boundary. It was a soft September morning of sun and golden haze, and Patrul was bowling up the valley towards the distant city, the mountains on his left, the heat on his back, the river glinting below him to his right, the road winding and undulating. He lay further into the extensions and his legs spun easily about his centre of gravity, a kind of little aura between the base of the spine and the thorax that beat out the rhythm and sent it gently pulsing back along the road through the endless ribbon of the rear tyre.

Sometimes, at the best of times, Patrul loved bikes. They were the perfect Zen of physical self expression, most when they were nothing, when all but the movement had ceased.

This was the kind of thing he always felt when he feared the coming of the Diablo.

You never heard it for long. First above the wind in your ears and the whoosh, whoosh of the gentle traffic, a thin tearing noise, becoming much too quickly a whine, going with absurd hurry up and down the scale of gear changes, no sooner into each cog than out again, and then, with nothing between you and it, no trees or good earth and rock to shield the ears, the unquietened howl growing to a scream, the jolt

of the bow wave as it hit your wheels, the instant's drop in pitch, the sculpted red plank on its four fat slugs shrinking down the lines of perspective like a deflating sausage balloon in profile, brake lights glaring, to the vanishing point of the next bend. The waiting silence, that will not be denied.

Patrul did not alter his cadence by a point, but his heart monitor recorded the event.

She was parked by a track leading up into the forest. He swung off the road, jittered on his eight bar 20 millimetre tyres over the loamy gravel and got off, hobbling in his cycling shoes among the trees, where he hid his bike. Even a training bike like this is worth a few thousand dollars.

He hobbled down again and, a condemned man, he squeezed himself through the gap between the raised door and the leather sculpting that ran along the top of the sill, into the seat that held him like a smoothly terraced coffin. The interior smelt of this leather, and of plastic and mechanicals, and above all of Perlita de Zubia. The turmoil of Patrul's inner space was confused some more. He turned to the waft of *lirios de los valles*, the tight dark curls and familiar face silhouetted against the glare of the handspan deep side window and, as far as the constriction would allow, gave a brotherly *bise* to her right cheek. 'You stink like a bear,' she said.

'And you like a ferret.'

She put an arm towards him, but it was arrested by the head of the gear lever, where she neglected it for a moment. He watched the arm. He watched it from the brown fingers all the way up the slender forearm, the palpable biceps, to the naked shoulder, the shadow of the arm pit, the outswell of her breast.

In lycra cycling shorts it is hard to disguise your true feelings. 'So,' said Perlita, looking down and sideways in shocked surprise, 'nothing changes. But I have ways.' He saw the muscles tense, the peasant strength still there, pushing the sideways swell of the breast upwards and outwards a fraction, and the gear lever clunked. The engine that had been burbling in a complicated way, suddenly barked ferociously. His manhood shrank like a worm into its hole, and at the same time

each part of him was clenched, comfortably but without question, by a false gravity. Then hell began.

Perlita was normally a very balanced young woman, but she had one compulsive disorder. Whenever she was in the Diablo, she felt the need – an absolute need, not a trivial challenge – to top 250 kph on every journey. Often Patrul had tried to persuade her that picking him up did not constitute the start of a new journey, but merely the old one continued. She snorted. The argument really offended her. But it was most important to him. Many roads, he felt, especially those that are not autopista, for instance ancient highways that follow river valleys, are unsuitable for speeds of 250 kph.

This difference of viewpoint was the grounds for their greatest friction, their nearly falling out. Perlita, being the one with her foot on the gas, always won.

Often, as today, things were hard. The cacophony was demonic, and his body was pressed every way round the horizontal plane, like a die being shaken in honey. They would come out of a bend with tyres howling, a few hundred metres of straight would sway and then stabilise before them like a quivering ruler, and about as wide, Perlita would bop the lever across to third and the engine screamed as hideous as a diamond cutter on titanium, the needle soaring past 200, 220, and just as she should change up for the last time, the dawdling Merc or Audi that had failed to clear the far bend would bring them to a surging deceleration that discomfited his eyeballs.

'Fuck,' said Perlita.

'I'd rather,' Patrul would reply, but it made no difference. He'd long given up explaining to her that training cyclists get killed or maimed by auto-maniacs far more frequently than one might hope.

Eventually it was done and Perlita dropped to around 150. Her upper lip glistened, and above the *lirios* Patrul caught the glorious peppery smell of her sweat, peasant yet. She swung up the next road into the foothills, the two metre wide car filling the whole track. Even now it was lucky that they met nothing, for she was still under urgent pressure. A few

kilometres on she swung again through a gap into a meadow, the bottom of the car rasping on the grass, bumping rocks, why the fuck don't you get a Landrover he had often asked, to a spat reply, to the shadow of the trees.

Perlita had not time for the slow elevation of the wing-like doors, but rolled onto the earth, jerking her skirt to her waist. Patrul peeled his lycra from pallid thighs. If the gods are watching us now, they will be sick with laughter. He descended on Perlita. All the work had been done. It was time to hurtle.

While those two dear friends of Akil Sáenz are at it, there are a couple of things to clear up. The first hardly needs an answer, because that's the way things are and if things are that way, they are. And so on. But, as Perlita would say to Patrul, she loved Akil, she respected him, and he was fine in bed, great, tremendous, superb . . . but – and this way, it kept her on the straight and narrow, so it was a very, very moral thing they were doing.

And what could Patrul, what could any decent man do but agree.

The second was more important. Patrul was on a training ride. That in fact is how Perlita always knows where to find him, because Patrul and Akil have a co-ordinated but not common training programme, sent through to both their faxes, with suggested but not compulsory routes, measured by satellite, because Fernand Escoto too has his narrow band of compulsion, to the nearest metre, front gate to front gate.

A discreet glance out of the corner of the eye. My god! OK, we have plenty of time.

Fernand Escoto. He has not been mentioned yet. That is not out of disrespect. There is no better team manager. A slightly plump man with soft dark eyes and a swooping, fleshy nose, he is one of those team managers, like Fleischman, who has never been a cyclist, and has got to where he is by sheer intelligence. It is not the place to go into the wide range of his abilities, as strategist, as psychologist, as trainer, as friend. It is to be hoped that some day a book will be written about him, far more interesting than the wearisome boastings of

these repetitious *routiers*, *grimpeurs*, muscle bound sprinters that clog the cycling presses. But another thing about Escoto is that he is not obsessed. He has his own family and his own life, and while he can be a quiet but implacable disciplinarian, he spends most of his time not being. So that when Patrul Azafrán explained to his manager in absolute confidence that just occasionally he had to meet a person, and as this had to be done secretly, solo training rides leant themselves very well, and as the person was married it had to be very secret indeed, and as the husband of this person was also a rider on the international circuit, if this thing ever got out, there would be fire and brimstone and utter cataclysm, from horizon unto horizon and to the tops of the very high mountains.

'In that case,' said Fernand Escoto, his soft eyes on Patrul's, 'I forbid you absolutely.'

'Unfortunately,' Patrul replied, 'it is not a thing over which I have control, the lady says. As my sincerely respected team manager, but also as a friend, I have to tell you that you have to listen to me. But I will also tell you every time it happens, so that you can compensate for the training deficit in future.'

'From what I have seen of your heart monitor data,' and perhaps Fernand smiled slightly, sadly, 'any such adjustment to your training should be made in the direction of relaxation after your – encounters.' He looked for a moment at the perfect nails of his right hand. 'Strangely, it is during what seems to be the period of foreplay that your heart rate peaks, actually somewhat higher than when you are pedalling at racing speeds. A woman's honour of course prevents one's asking. . . .'

And one's replying. De Zubia's driving habits are public knowledge.

'At any rate, if your heart was not so secure, I would have worried about it. The young woman in question, once physical contact is made – I am able to tell you this not because of any prurient snooping but because of strong interference patterns, partially, it is true, but not wholly damped by, as the computer reads it,' Fernand dropped his eyes modestly, 'by pudding basins of bouncy flesh – also has an exceptional heart.

So you are both lucky. But it is dangerous in other ways.' And he looked severe.

And that exceptional heart has now quietened to perhaps twice it's resting rate, and Patrul's, being in the condition he is, is within a few percentage points of resting, though thudding about his body a bit yet, and we can continue with their conversation.

Perlita got out the small rug that filled the entire luggage space of the car, and they perched their bums on it and lent back against the door – not entirely comfortable because of the air scoop to the rear discs – knees up, drying in the sun.

'They're going for Akil, aren't they?' You wouldn't think she'd had anything else on her mind coming to that place, you'd think the question was the very first thing that occurred to her after they got out of the car.

'You have a theory?' suggested Patrul.

'Look what happens. Akil is about to become the greatest rider of all time, and then two deadbeats come from nowhere.'

'Not deadbeats, come on. We less than perfect deserve some respect. Jan and Ernesto were top rank – if it hadn't been for Akil either could have been three time Tour winners, easy.'

She shrugged. 'The fact remains, they come out of the trees and upset the balance of nature. Then they are killed. Also they go very peculiar in the head. What does that mean?'

'Post hoc, ergo propter hoc,' – this guy Azafrán, for a self-educated bike rider, sometimes you've just got to admit he's fantastic – 'is not a logical way of dealing with things. Just because they get funny in the head after they start to win, it doesn't mean one causes the other.'

'Twice?' shrieks Perlita.

OK – not strictly scientific, but not to be ignored. Patrul's already come to the same conclusion. 'But where does Sáenz come into it?' He likes to keep his compañero at arm's distance on occasions when his thigh naked to the waist (he hasn't taken off his QuantaLogiK jersey) is edge to edge with Perlita's silken and honeyed.

'That's what we gotta find out. He does, I tell you he does.' She shook her curls, still a bit damp on the neck and brow. That Patrul, romantic bastard at heart, tried to kiss just the point the moist tresses brush the shoulder, but she shrugged him off. She's very single minded, de Zubia. One thing, or the other. She goes on. 'Well, let's see – the murders are to get rid of the evidence – no?'

'Not necessarily. The murders *seem* as if they are to get rid of the evidence but at the same time, they *seem* as if they are to point out precisely where the evidence would be found. That is to say, you don't butcher a guy and take out his brain in those circumstances if you don't want the world to guess that it's in the brain that the evidence lies. So somebody is playing games. That's a smart thing to do. The more you play games, the more you multiply the possibilities. It's also a dumb thing to do. The more you play games, the more you leave your personal mark. It's like a perfume.'

'And who does it stink of?' asks Perlita.

'It stinks of somebody with a sense of fun.'

'But they're not doing it *just* for fun.' She spells it out. 'Supposing Potocki hadn't disappeared, supposing Sarpedón had been allowed to go on living. He'd've become more stupid . . .'

'Saintly,' corrects Patrul, always prepared to think the best of a guy, even an ex-professional world class bastard like Ernesto.

'Not saintly. Saints always have a song and dance routine, a big story already lined up. Saintliness is a bit self-belief, plenty acting, lies, and most important having a good agent after you've snuffed it. No, Ernesto was never saintly. He was more like a sheep.'

Patrul frowned at the bright sky, trying to recall the Tour winner, trying to fit him into a fleece and make him bleat. No, more like a lousy wolf, that Sarpedón. 'Sheep I don't see,' he said.

'And old people, you know, that thing . . . staggers.'

'That's just hens.'

They look into the distance a little while.

'Don't make those popping noises with your lips.'

'Thinking,' says Patrul.

'Well talk, don't pop.'

'People bumped off, standard package, bullet through the back of the head, hit and run, pfff. But elaborate stuff like this . . .'

They should have discussed more. With a third death just around the corner, they should have shown more persistence in their care for their dear friend Akil, but Perlita suddenly switched focus again from the one thing to the other. There is no point in waiting. When this is over, it will be time for Patrul to find his bike – after the fear and the excitement precise memory is not so good, and this can take a long time – and continue with his paid employment.

Stage 9

Oh, the third death was Agaxov Fynbo. Agaxov had gone missing on a training ride from his home on the Arno. His sad Latvian wife, used to tragedy, had reported his failure to return to the police, who'd immediately set up a search. His body wasn't found that day, but the next it emerged with the dawn. The initial series of police photos – first from across the glorious shell shaped space, then in increasing close up; finally a series of macros of the detailed finish, the welding of red wax to white bone – the work was comparable in craft to that of the great frame brazers of old.

'Violence transcends the bourgeois universe, horror *is* art' – Galaxie-Cyclasme joining in the orgasmic screech of the intelligentsia. Sure it's fine to slap prints as big as shop windows across public galleries and squares. So what the feelings of the man's family should be respected, his small children, his tear-stained Baltic wife. Agaxov Fynbo. Hombre tonto. Cyclist.

What the artist had done with Axo's body was, he, or she, had rendered it half flesh, half polished skeleton. The skull, for instance, was stripped and hollowed and whitened to an ivory shine. One arm was whole except for the forearm of buffed bone. For the other, the forearm was clothed in skin and muscle, but the hand and humerus were naked of all flesh. As was the opposite scapula, the acromion and coracoid processes and the clavicle. The legs had had the same treatment, unfleshed femur white above swelling calf and skeletal foot, twinned with the pale minimalism of tibia and fibula between perfectly muscled thigh and the boundary where the meat began again at the trochlea of talus; the treatment of the legs and arms reversed to retain a complex symmetry.

The discontinuities had everywhere been finished with fine red wax, so neatly that the substance seemed a metamorphosis of the skin sweeping swift and crimson in to meet the bone at right angles without leaving the slightest crevice.

This invention emerged with the daybreak because it was hung halfway up the Torre del Mangla high above the Campo in Siena. Even as the light strengthened, the growing crowd of those who start work at dawn could not decide whether what held them was corpse or carnival. It was only when a police rock-climber abseiled down from the bell platform that human remains were confirmed.

The half of Agaxov that was yet flesh was unclothed, but the sharp-eyed could make out the logo on the casquette pulled square, as riders themselves do when they lead across the line, onto the skinless dome – QiK.

A death not of Fleischman's own, but in the principal rival team; of a rider, not top class, but – to make a posthumous assessment charitably – with specific talents uncomplicated by insight or understanding; and the corpse flaunted not five hundred metres from the home and laboratory of the Cosimo team manager. It seemed like either somebody was trying to simultaneously point a finger at, and away from, Mikkel Fleischman. Or, even more complicatedly, somebody wanted things to look that way.

Stage 10

There is no law by which you can do a biopsy on somebody if they don't want it. There isn't even a biking law. Urine you can take to test for drugs, yes. Bits of body tissue, blood, brain, no.

A bike rider who suddenly starts to win races out of the blue is not committing any crime. That rider is not going to say, 'Yes, drill holes in my skull, take nuggets of my brain, suck out a centimetre or so of my liver, a few juices from my pituitary, my thymus. Drill the white walls of my bones, sniggle out slivers of marrow. Come, good people, do what you like with my body. What right have I to care?'

He's not going to say any of those things. He's going to say fuck off.

Especially if he has just started winning big races, Paris-Nice, Milan-San Remo, the Flêche Wallone, Liège-Bastogne-Liège, nose to tail.

Like Ettore Baris.

It's all there in the accounts. In the record books, the journals. The police files. Oh yes, by the time Baris had won his second major event the police were shit scared. Interpol had co-operated with a twenty-four hour watch on Ettore immediately he'd beaten Akil by thirty-seven seconds in the Milan-San Remo – confirming the two minutes twelve he'd beaten him by in the Paris-Nice as more than luck. By the time he'd won the Paris-Roubaix they were paranoid. And that was only the start. Next came the Giro d'Italia.

The Tour de France is the biggest of all time, but the Giro d'Italia can be an extremely hard race, hard like edges of ice, not just difficult to pedal. To reach the top of the 2300 metre Roncoli de los Machos Cabríos in a freezing sweat, and then have to descend through the snow, to negotiate the ice-sharp hairpins when your body is locked with fear and hypothermia, these are more than the ordinary pain of racing.

Maybe it was religion that kept Baris supple and warm.

Certainly he did not make out like a robot like the late Potocki or Sarpedón. But he did enter a deep and on-going relationship with God.

There was nothing unusual in Ettore Baris being a good Catholic boy. It was having a priest with him at the roll-off that was a bit of a talking point. This priest was short and stocky. One eye was green and one was brown, he had a full beard clipped short and to a point at the chin, and a sharp nose. He was called Father Blériot, and he seemed to be always angry. He'd accompany Baris to the start line in his cassock and then, while a gofer held the bike, the two would kneel in prayer. Before he started praying, Blériot would glare around for hush.

The guys had a bit of trouble with this. The rural Spanish and Italians and French were particularly confused. Pious as fuck with their mothers, off to mass in tie, suit and hair gel without ever a question about the nature of the Trinity having crossed their minds, they had the other side to them, the badboy side, which thought that priests were jerks.

On the fourth morning, after Baris had won a stage and opened up an overall lead of a minute and a half, three Australians and an American knelt in a circle with the blessed pair. Fr. Blériot glared at the smirking faces and accused them of sacrilege. 'Come on, sport, fair's fair,' Chas Stongo spread his hands in mock anger, 'the routine works a treat, it's restrictive practice to use it on just the one guy. Put it about a bit. Pretend you're a Christian. We'll all divi in.'

'Ta gueule,' said the priest.

Stongo held up a fist. 'Yours too, mate.'

Fr. Blériot started to get to his feet, and it would have been an interesting fight, one for the cameras, but Ettore gently pulled on the holy man's sleeve. 'Brothers,' he said with a soft smile on his lips, 'cannot we be at peace. Brothers, if you will share with me the love of God and of his only begotten Son, and his mother Mary, kneel in all humility with us. Bear in mind that I do not pray to God for victory, or any earthly thing, but for His love and forgiveness, for my immortal soul, and the souls of all my brothers.' He smiled round, one of

those smiles so without malice or scorn or anything but radiant goodwill that you want to feel the guy's teeth giving way on the end of your boot. The Aussies couldn't take it and went back to their bikes.

Baris and the priest continued to pray and then the priest blessed Baris's bicycle with some holy water. They say the *directeur sportif* of the GLOK team actually went through the rule book to see if there was anything about additives that would cover holy water so one could launch a protest and have Ettore docked ten minutes. But there wasn't.

Akil could not see it as a joke. He hadn't laughed for a long time. Before, he'd known in his heart, despite his ambiguity with Gomelez, that he'd been beaten not by a better rider, but by some corrosive agent as yet beyond analysis. But Baris, apart from the religion, he seemed to know what he was about. He even needled Akil. 'God moves in a mysterious way,' he said to him as the bunch was getting a little warmth in their legs in the first kilometres of the stage, 'just you watch me.'

The previous evening at supper Escoto had told Akil he must win this stage. He was sitting directly across the table and in his silky tenor voice he began to speak so the whole team could hear. They listened. He started slow and quiet and then cranked up the pace and volume until he was nearly shouting '. . . You feel weak, right? You feel hurt, right? You've done not one thing good for the last couple of years – OK, a Tour de France when poor old Jan lost his way, a Worlds, nothing *consistent* – and now your feelings are hurt too, because kindly Fernand Escoto is being beastly to you. You can feel the anger and the tears pricking behind your eyes, and that makes your hands weak, and your legs weak, and your *heart* weak. You feel like water now, eh, Akil Sáenz? Akil Sáenz – huh! Yesterday's man.'

All the guys looked hard at the table, at crumbs, into their glasses. They expected Akil to get up and deck Fernand. One guy didn't look at his fingernails. Azafrán. Patrul looked at Akil. They both had tears running down their cheeks.

'Well you better get the fucking weeping and wailing done

tonight. We don't want any screeching Madonnas on the start line tomorrow.'

It was the only time any of them had heard Escoto use profanity. He let there be silence for a full minute. 'Now we discuss tactics.'

<p style="text-align:center">★</p>

Climbing a horror like the Roncoli de los Machos Cabríos in May, when the weather thinks it's February, you would always rather be somewhere else, somewhere warm, and sunny, on a hot beach maybe, where you are lying down and soaking up the sun and doing sweet fuck-all, oh how sweet and warm fuck-all can seem when you're grovelling up the Roncoli De Los Machos Cabríos through the flopping angel turds of wet snow.

The quicker you get there, the shorter the pain. Tiss, Carabuchi, Villeroni, Lostwithiel, Gestalt and Narabellini went off the front like little ice pixies, a hot shower the only feeble glow at the end of a tunnel of grey despair.

Cosimo kept to the front of the main bunch until ten kilometres before the climb, by which time the lead group was away more than four minutes. Right up against Cosimo was the whole of the QiK team, Azafrán with Sáenz tucked in behind him to keep sheltered from the north, and seven good men around them like a bodyguard, preserving them from justle and shock. Then Patrul notices a sort of clenching of the Cosimo knot round the back of Baris. 'Ready,' he growls to his fellows. Everybody is nervous. Patrul's 'ready' squirts more adrenalin. Legs begin to tremble. It's the same with the Cosimo guys. It's crazy. You can shake so much you feel you can't control your bike. And it's not the cold. There are sixteen riders doing forty five kph plus, and they couldn't put their elbows out without taking up more of the road than is available and suddenly, whether it was a signal or someone just couldn't take the tension, like a whole flock of birds changing direction all at once we're off, the pace has momentarily upped three kilometres and it's bedlam. Baris goes to the front to be out of harm's way, and his team gets

behind him, two, one, three, trying to block off the road. Two of our QiK guys force through on the right abreast, get level with Baris, and then start a line on the right of the road. Patrul and Akil fall in on the tail and the other four follow and start moving up, but Baris ups the pace once more and at the same time two Cosimo guys squeeze across and cut off the last four QiK boys from Akil's wheel. The QiK guy at the front moves to the left, drops back to get his breath, squeezes the Cosimo guy off Baris's wheel and Akil goes past. Three Cosimo guys claw past us in echelon on our right, and Baris slips from his team-mate's wheel onto Akil's. It is frantic and energy sapping and it goes on for several minutes and nothing comes of it. Then like the passing of a hectic windstorm out of a clear sky it is over and we settle down into the previous pattern, just shadowing Cosimo, letting them do the work, letting Baris sit at the front. By now we have left the bunch a minute behind, and are reeling in the lads up the road fairly fast. We get to them at the start of the climb, and Baris uses the distraction to take off on his own. Sáenz and Azafrán chase. We have been here before.

Within a hundred metres there are only three people in the race. Baris, on his wheel Sáenz, and on Sáenz's wheel, and breathing harder than he wants to, Azafrán.

And now, be lifted suddenly into the sky. We have to put up with the constant roar of the helicopter, so let's make use of it. It is a curse, battering the nerves, and a practical danger, because one of the warnings of an accident round a corner is the squeal of brakes. With the helicopter above you don't hear it. You just plough into the spilt bodies. So we will get out of the dire machine what we can.

From this height we can see the main bunch who have not yet gained the lowest slope. Then, on the slope but waiting for the peloton to join them, so the bitter mountain may be taken with as much shelter as possible, the Cosimo and Quanta-LogiK teams, and the young Turks from the earlier attack. Then higher up, three little figures, who break into one and two. And this time it's not Patrul going off the back, it's Baris going off the front, the TV bike sweeping on ahead of him,

looping up through dirty icefields, leaving dark tracks on the road greyed out with newly fallen snow. Rocks and crags are black, the sky whitish grey. Clumps of spectators, few, are smuts on sodden newsprint.

The leading rider is widening the gap on the second pair. The gap is like old elastic between them, stretching, holding, losing its resilience, falling apart without a twang. Baris is on his own.

Time passes. Much later, now a terrifying kilometre up on the QiK team leader and his lieutenant, Baris reaches a larger knot of spectators. He stops. The gap begins to close quickly. And now behind Azafrán and Sáenz the peloton are also closing, like a slime mould moving up a wall. The QiK pair go past the spot where Baris ceased to move, perhaps pausing slightly, it is hard to tell at this distance. What can have impeded the race leader – some idiocy? A signpost? A giant frog? Neither is likely on this cold mountainside.

Perhaps he has blown up, perhaps it is the fringale, the sudden gnawing rat of hunger and cold that leaves a sickening hole where your heart and strength used to be. From here in the warm, roaring cabin of the helicopter, it is impossible to say.

But look, just before the peloton arrives at the knot of crowd the lone rider, Ettore Baris, moves off once more. He looks like one of those toy monkeys that slide up a string. The string is stretched between the peloton and the stage leaders. The monkey is moving up it smoothly and fast. In ten minutes he has hit the stop, he is up with Sáenz and Azafrán again.

But he has found another string, it seems, between the pair and the summit a couple of kilometres above. Baris continues to move up this other string as smoothly as before. He reaches the top of the pass two fifty metres in the lead, and then – we fly lower just to get the detail of the spectacle – he descends as if he was literally in the hands of God, the omnipotent fingers either side of him, here gently catching him as he leans too far over the edge of the precipice, there taking the shock with instantaneous adjustments of gravity as he slides within millimetres of overhanging cliffs lanced with ice. We are above

him, but often he is laid so far over on the unpredictable surface – here good metal, then slush, mud, deltas of grit – that his wheels are not lines, scarcely ellipses, but near perfect circles to our eye.

Ettore Baris finished that stage three minutes fifty seven seconds up on Akil Sáenz.

And what if he hadn't stopped on the ascent? By how much would he have won then? Ah, but the prayers were necessary for the descent. He affirmed this in his first post-race interview. He had suddenly seen, among a small group of hardy and cheering fans, one of those little roadside shrines to the Virgin – and he'd known beyond doubt that a short prayer for intercession was what to do next. No matter that the main threat to his lead was storming up the hill behind him. All things in their own time, first the sacred, then the things of the world.

Fleischman made no attempt to intervene. He sat quietly in the front of the team car with the window down watching the kneeling figure in black tights and a shocking pink thermal jersey much bedecked with logos (In the beginning . . .), probably hoping to hell that the snow would not make his *campionissimo's* knees seize up, but remaining outwardly tranquil.

When Ettore rose and took up his bike the two men acknowledged each other with quiet smiles, and it was only when he had snapped into the pedals and stood on them to power up to his previous steady rhythm that he raised his head and looked up the road to see whether his adversaries had come by him – the cheers when they passed him had been muted out of respect for his devotions, and had not intruded. When he saw them far above the next bend, he buckled down to work, assured by the Virgin that God would prevail through him both in his going up and his coming down.

Thus, he said, his crushing victory at the top of the col. Thus his miraculous descent.

In the QiK hotel that night, despair. Akil wanted to pull out. 'You're raving mad,' said Escoto, 'you are lying second in the second most important stage race in the world. You are

not sick. You are not injured. You have responsibilities to your sponsor, your team, your team-mates and to me. How can you talk of pulling out of the race?'

'No, I mean pulling out of cycling. Pulling out of life.'

'That would be more sensible,' said Fernand. 'But no, it is not allowed. Suicide is not allowed in your contract.'

So Akil carried on racing, and came second in the Giro d'Italia. Patrul Azafrán was third incidentally, his highest placing in a major stage race, and a stupendous result for someone who was working his heart out so dedicatedly for his team leader and his sponsors.

Stage 11

You cross the river at Ventas de Yanci and come to a little village. The restaurant has a red tiled floor, and they do hake baked with a fistful of garlic like nowhere else in the world.

Between the Dauphiné Libéré and the Tour Patrul came home for a few days. This was partly to rest himself, and partly to work on Akil's state of mind. The pair had been for a long spin that day, six hours crossing into one country and then the other and back again as they threaded the mountain passes. They were tired and hungry. Perlita decided to take them to Los Alcornoques for a good meal, and even a bottle of wine. *Merluzza con ajo* with five loaves of fresh bread is a dish that has more to do with the roots of being than with fashion, so the three were recognised only in homely, comfortable ways – either by locals who knew that the great Akil Sáenz lived thereabouts, and had perhaps seen him from time to time flash by, legs dancing and spokes whirling in the sun – or those who knew nothing of the sport, but were struck by the beautiful couple in their rich, casual clothes, and the wiry fellow who was their companion, a look of wise vitality always about his countenance whether it was laughing or grave. Nobody came for autographs, or tried to take part in familiar chat – the wave, the smile, the clap on the shoulder, they were enough to know it was good to be home.

'If you look at the results statistically,' Akil was saying at one point, 'and ignore the deaths, then you could suppose that the explanation is simple. My relative performance has dropped. I have become the permanent second place man. Perhaps soon it will be third, and then exponential. I shall finish the Tour in 55th place – or 155th, who cares.'

It is the duty of the fidèle équipier, when his patron is feeling like this, to catch him as he falls and buoy him up. 'But you cannot ignore the deaths – three of the lads have been murdered. You *can't* leave that out of the equation.'

'Are you sure?' Akil looked at the other two with a sort of

scrabble of the eyes, as if his brain had slipped a cog under tension.

'Of course, my love' said Perlita, laying a hand on his. 'How could those deaths not be important?'

Akil studied her face for a moment. 'Do you ever wonder whether all the world is in the know but you? Whether everything is being done by arrangement, like one of those secret parties where you are taken to an empty place and then they switch the lights on and there is everybody from your life, friend and enemy, laughing and shouting and waving coloured paper, and there are you, like a child woken from sleep in a strange house by a face you do not recognise.'

'My love,' said Perlita, so Patrul even felt a bit uncomfortable, as if he'd done one or two not quite good things in his life. 'My love,' and she moved her hand from Akil's to the inside of his elbow, and with one finger gently stroked the smoothness there.

'But do you?' he persisted. 'I never saw those things. I saw Jan looking at the signpost, sure, I saw Ettore praying to the Virgin by the side of the road. I never saw Ernesto carved up like a pig, I never saw those terrible bizarre things they did to Agaxov, I never saw his body hanging from the tower. These could all be stage tricks, so easily they could. It could be all planned out. It would not be hard to keep me in the dark. I am a bike rider, not a man of the world.'

'You're a man of the fucking world, Akil my friend,' says Patrul, '– and anyway, what about us?'

'What about you?' He leans away, looking from one to the other and back, and back.

'Hey, hang on a minute, is this what you're saying, are you saying there is a plan against you, and we here, Patrul and I, you think we're part of it, is that what you're saying?' He ignores her anger. His calm is disturbing.

'You must have felt this too, both of you, at some time in your life. There is a plan. It doesn't make sense to you, not at all, but that's because you are outside it, you're a kid outside the door and all the grownups are inside, talking and laughing.

'The world is taking a lot of trouble with its plan for me,

that's for sure. But, doesn't it seem logical, if that is the case, you two must be part of it. Yes, let us face it, you two are not me – so you must be in the know, in on the plan?'

He looked from one to the other, with that two second rhythm, as if he were leading us rather quickly through a set of accounts or the correct procedure for servicing an advanced domestic appliance.

'You must have had these suspicions yourselves.'

'Yes, yes, there's sometimes the fear that people are laughing at us, that we've been set up – of course there is,' says Perlita, not touching him now, not sympathetic, very matter of fact. 'Sure everybody is paranoid from time to time. But look, has anybody ever approached you about the conduct of *my* life, given you *your* part to learn, *your* stage directions?'

'No.'

'Well then?' She smiles, desperate to dissolve the dilemma in laughter

'But even if they did,' he muses for a few seconds, 'that would still be part of the plan.'

'Yeah, that's logical,' Patrul agrees. 'It's watertight. It's a complete theory of the universe, bollocks and all. To be honest it *has* crossed my mind from time to time in the past – everybody's, I imagine. The thing is, do you believe it?'

'Did you?'

'When?'

'When it crossed your mind?'

'No. If I'd believed it, I would now be mad.'

'And am *I* mad?'

Patrul looked Akil in the eyes, lips slightly compressed. Then he shook his head, like a doctor who has been asked for symptoms of the incurable and can see only health. But for the first time he began to wonder.

Akil turned to Perlita. 'Am I?' he asked, in a low, ridiculously dramatic voice.

She suddenly grabbed him by the collar of his blue silk shirt. She brought their heads close together and spoke quietly, so that those at nearby tables should not hear. 'Look, dear heart,' she growled, 'not you, not me, not any of us are

powerless creatures, we are not knickers in the world's washing machine. You who can ride up mountains, did it ever occur to you that the rest of us have to be responsible for ourselves, for making ourselves into real people who can get up in the morning, go to work, talk to others, go out for meals, discuss the crises of life. That doesn't just happen. That's because you have to have the courage to decide what you are, and the energy to be that person. That's up to you. Nobody else does it for you. You. You are not mad. So you can decide. You can decide to be a sane person, like you always have been. Or you can decide now you'd like to be a mad person. In which case, fuck you.' By this time she had both sides of his collar wound round her strong fingers, and it was getting a little loud. After 'fuck you,' she pulled their lips together and gave him a violent kiss. Everybody was watching. Then they sighed and turned back to their plates and glasses and friends. It was all very *jondo*.

Akil said, 'But who is this "I" who must decide what I am to be? That must be another "I", yes?'

'Oh for fuck's sake,' hissed Perlita.

'OK,' said Akil. 'For fuck's sake it will have to be.' He smiled like his normal self. 'I'm going for a piss.'

Immediately he was gone Perlita said, 'Patrul, you have to do something quick.'

'What?'

'Sort the whole business out.'

'Oh yes. How?'

'Patrul. Please.'

He had been told, for love, to descend into the underworld.

'Don't look so hang dog. Go and see that Gabriela trollop.'

'Sure. I have a spare day in my pre-Tour programme.' He said this ironically. Perlita didn't get the irony. She had other things on her mind.

'But Patrul.'

'Light of my eyes.'

'You're not to fuck her.'

'Dear, I think she'd rather you.'

'OK, you can fuck her from me.' What strange uncouth

74

things women say in those little gaps of time between significant events.

When Akil came back he started to talk, as if it were his sole concern, about titanium. Nonetheless Patrul decided to go and consult the only judicial person whose interest in the case had suggested that she saw the violent death of cyclists as more than a marginal phenomenon, something indeed without the law.

Stage 12

Patrul Azafrán did not get a very long interview with Detective Inspector Gomelez. She was certainly not prepared to leave her office and take a little drive with him to the Desfiladero de Despeñaperros, the ravine of throwing dogs over the cliff. 'Why?' Patrul demanded.

'The means of disposing of dogs? – I haven't a clue, I am no more from these parts than you,' sighed Gabriela. 'Also I am on a tight schedule. It seems a perfectly adequate method. I have a meeting in ten minutes.'

'But I have made a considerable journey by aeroplane and hired car, carrying my bicycle.'

Gabriela lit a cigarette. Under any other circumstances Patrul would not allow his lungs to be contaminated by smoke, especially in the week before the Tour. Now he just waved away the plume that she blew around him, then apologised for his vigour.

'That's all right,' she said without smiling. 'What's your interest in the case?'

'I am Patrul Azafrán,' he replied.

'I know that. You introduced yourself when you came in.'

'I am Patrul Azafrán, équipier fidèle of Akil Sáenz. And you ask me what is my interest in the case!'

'That's right.' Gabriela blew another plume of smoke over his head. 'You see, I have no interest.'

'But you are the investigating officer for the death of Ernesto Sarpedón. How can you say you have no interest? Has that mystery been solved?'

Gabriela had on jeans and a black shirt with just a few buttons done up – it was a hot day – and nothing else apparent. She smelt of Viburno 'bitchi' and her hair was short and spiked with gold. She leant forward. 'Ah. There is a mystery?'

'You know who killed Sarpedón?'

'I would have thought so. Is there any doubt?'

Patrul made a humorous face, frowning and with the lips pushed out. 'You know who did the actual carving?'

'There too there can be little doubt. The Zoto brothers.'

'You don't really mean that.'

She just stared at him.

'But they are dead men.'

'Look, chico, how do you know a bandit when you see one? A bandit is a guy from a spaghetti western with not much personal hygiene and lots of leather and nickel about his person, also wearing a wanker's hat.' She did not seem very much impressed by the machismo typical of the region. 'I have spent some time in Venta Quemada and a very reasonable and decent bunch of people they seem to be. There are those, and no doubt overpaid pedal pushers are amongst them, who think that peasants are – traditional, syncretic, collectivist in their intelligence, such as it is. I am not amongst them.'

'Hey,' said Patrul. 'My granny picked crocuses in the high mountain pastures.'

'Her floral habits have a bearing?'

'For saffron. Don't you tell me anything about peasants.'

'Then we are in accord on the subject. The evidence from Venta Quemada – that three stinking bandits did appear, calling themselves the Zoto brothers – is overwhelming and I think irrefutable.'

'What does "syncretic" mean?' One of the ways Azafrán was able to transcend, though not abjure, his peasant roots was by this constant, humble search for knowledge.

'What the fuck has that got to do with anything?'

'Quite,' Patrul chivalrously agreed.

'We know who did the killing. Mere agents – and we have not yet found their lair in the mountains, or in the barrios of Marseilles or Naples or Gibraltar. Indeed it is highly likely we shall never find the killers, unless we can ensnare the substantive murderer, by which I mean the one in whose name it was done.'

'And you know who that is?'

Again she said it. 'Can there be any doubt?'

Patrul blinked at her, wide eyed, waiting for the name. She

merely brought her eyelids together until the lines of fluid glittered, and blew smoke at him, stubbing out her cigarette.

'May I make an observation,' Patrul asked. 'That is a habit that is both unpleasant and provocative. The provocation of its nature breaks equally into two parts, one of which is aggression and the other sexual invitation. As a professional cyclist who must at some time today, amidst my other commitments and, I hope, pleasures, get in a short four hour training session preparatory to the Tour de France which starts this very Saturday coming, I am having difficulty with the aggression, the sex, and the smoke. Could I perhaps without causing offence request you to communicate in another way?'

'Don't bank on me for any pleasure, chico.'

'Could I ask – because I am without doubt one of those new men, and have no hang-ups about differences in sexual orientation . . .' Gabriela drew in her top lip so that the new cigarette in her mouth jerked its unlit end towards the ceiling, then applied the flame and blew some more smoke at him. He deferred the question, and took up the previous thread. 'So you think the person responsible for these three deaths is . . .'

'My dear Mr . . .' she pretended to glance at her notepad '. . . Azafrán. I know who the murderer is. I assume you know who the murderer is. But the focus has been entirely lost. Agaxov Fynbo's death saw to that, as it was meant to. You see, to most of the world cycling is a very boring sport. Indistinguishable men in unfortunate costume pedal – a repetitive process in itself – for hours, sometimes days on end, and then they come to a place where they stop. That seems to be it. So don't expect those who count, the metropolitan citizenry, to be remotely taken with the bicycling aspect of the case. No, no, what does thrill us to the urethra is the promise of a serial killer. Serialisation turns a loose collection of one-off abominations into a coherent epic of the repulsively macabre – you get the singles and you get the album. Thus, this is the story of a serial killer who has a pathological relationship to the male fork covered in lycra. The case becomes a simulacrum of the simple array of tabloid signifiers which are supposed to analyse it. All content,

political, commercial, philosophical, which might lead us to the precise and individual criminal responsible, is jettisoned to preserve the lowest common denominator of populist gloss. No, Señor Tulipán, I'm afraid that with the suspension of your altered friend from the parapet of la Mangla this thing has been dissolved from its context of law and criminality and floated off by computerised special effects into a magical region of totally de-historicised aesthetics.'

'Has it?' said Patrul, feigning not to have entirely under-stood her every word. Then suddenly, 'In that case what chance of bringing the criminal to book?'

Gabriella smiled at him a hard smile, a hardness that showed that she was displeased, even maybe offended by the turn of events. 'I have no interest any more.'

'You've been warned off.'

'Don't be absurd. The situation warns me off. The killer – and if his identity is obvious to us, it must be obvious to anybody else who's interested – has managed with a great deal of organisation, and therefore by definition of money, to achieve three crimes on which the police forces of Europe have drawn a virtually complete blank. It sounds absurd, but apart from the circumstantial evidence not one connection can be established. There is a fault line. We can work back, especially from the death of Sarpedón, to quite specific things, like the hiring of a helicopter. And then there is a dislocation, a fault, a time/space anomaly. Extrapolating forward from the murderer, we come to the other side of the same dislocation. All we have to do is jump that gap.'

'Isn't that easy enough?'

'Go on.'

'I don't know. Examine Ettore's shit.'

'Nothing could give me greater pleasure. You have some with you?'

Patrul felt over imaginary pockets – it was a hot day and he wore only shirt and slacks.

'Oh dear,' he said, 'I seem to have come out without . . .'

'State visits used to be a problem, especially in that era

when superpower leaders were chosen on the grounds of their senile decay. The host country used to lay traps of lavish and luxurious water closets with curious flushes of worked gold, pans encrusted with diamonds to lure down the softening entrails of the visiting World Leader. In countermeasure the visiting security chiefs, before the global statesperson made any unscheduled visit to a comfort station, would insistently remind him of the absolute necessity of never letting a smidge of crap hit the pan – otherwise it was off to the laboratories with it and an exhaustive printout of all his body's ills was suddenly global property.'

'I could do that,' said Patrul, 'I'm handy with drains. There must be a manhole cover near Ettore's house.'

'He has a police guard.' Gabriela shook her head as if to a bewildered child. 'They are guarding him from the assassin. You go poking about in his sewer outlet, you will be shot dead. Not just dead, but with many extra holes. I don't advise it.'

'If the police are guarding him, why can't they do it?'

'It is not a legal procedure.'

'Hell, no but I mean, unofficially – once they *knew* what he was taking, then they could work out an official way of finding out what it was.'

Gabriela's shrug suggested that Baris's guard might have been chosen more for their shooting skills than for their dedication to an abstract notion of justice.

'Fair enough,' sighed Patrul. 'There is nothing else you can tell me?'

Gabriela shrugged again.

'Just one thing,' he implored.

'Yes?' She pretended to await a precisely formulated question.

'No, I mean just tell me one thing. A treat. A surprise. Tell me one big, straight, useful thing that I do not know at the moment.'

'Syncretic means "all sorts of rubbish all mixed in together",' said Gabriela, and stood up to shake hands.

Her shirt was as far open as a man's. Patrul made no attempt

to look as if he wasn't looking. He gestured towards her chest. 'For me it is a matter of genuine regret . . .'

'Perhaps another time.'

<div align="center">★</div>

Azafrán waited until he saw Ettore Baris in the distance, gliding up the false flat in a middling gear, smooth as fluid, rhythmic, swift but unhurried – he had all that Akil Sáenz had, save that final intimation of exorbitant power, a power that should only seldom be released; except, Patrul reflected as he clicked a foot into a pedal, sprung the bike forward, snicked in the other foot and accelerated to a speed where he would be able to fall in beside the current world number one – except that it was Baris now who had the exorbitant power, so he could stop to pray at roadside shrines and still win stages, whereas Akil had to scrape along the very top of his ability, and yet be second best.

'The peace of God be with you, brother Patrul,' shouted Baris as he drew level, far out on the left side of the road. At the same time a car which Patrul had heard approaching, which in fact he had already assumed to be the police guard that covered Baris day and night, jammed hard to the right as it thrust between them, forcing him to turn into the verge with a braking skid that left him lying by his bike, the front wheel glittering quietly in the sun, his right foot still locked in the pedal, and blood starting from his ankle, the outside of his knee, his elbow and, through the lycra, from his hip. A second police car swept through in Baris's wake.

'You fucking . . .' and then a considerable catalogue of impolite things he imparted to the two plainclothes cops who had leapt from the first car and now stood over him with pistols pointing down his throat. 'Don't you realise I have a race starting on Saturday?'

They were big fleshy men, the kind whose bulk makes their feet look small but still manage to move in a way that dissuades you from trying anything on with them, especially when you are lying on your back with your foot locked in a

pedal at the other end of which is a complete bike. Patrul tried to sit up.

'Stay just where you are,' said the one with a beard and moustache. 'A bullet through the knee isn't going to help your chances of competing none.'

'And we would be sorry for that,' said the clean-shaven other. 'We are, you see, aficionados of the sport.'

'Which brings us swiftly to the point – why were you trying to drive the man our car has been detailed to care for off the road? In what ways were you going to further assault him once you had forced him to crash? What was the technical nature of the damage you were about to inflict?'

Patrul sank back to the ground. 'I did nothing. I wanted to talk to him, one professional to another. How dare you suggest I assaulted him.'

'Oh look, you've cut yourself.' The smooth-shaven one demonstrated the place by drifting the thin sole of his fine black leather shoe over that small knobby bone on the outside of the knee joint, gently forcing the little black grains of gravel a few micrometres further into the livid tissue. Then he wiped his foot on the dry grass.

'That should be cleaned up quickly,' said the bearded one. 'Otherwise it might turn nasty. Of course you assaulted him. Otherwise we wouldn't have found it necessary to take measures, would we? But no harm done.'

'Just a bit of sporting rivalry, we expect. Not our remit. You didn't want to kill him, did you?'

'No,' said Patrul with glum irritation, 'I did not want to kill him.'

'Good,' said the smooth one. 'Why don't you get your foot out of that pedal, and get yourself over to the vehicle, and we'll see what we can do with that leg.'

The uniformed guy in the car did a fine job with the hydrogen peroxide and a light dressing, and when Patrul got back on his bike ten minutes later, having signed autographs all round, and extra ones for the kids, he knew that his leg would be all right for the Tour.

'So you just wanted to talk to Signor Baris,' said the

bearded one, full of sympathy, supporting him as he locked his feet in place. 'What a pity you didn't ask us first. I doubt you'll catch him up now. He seems to have quite a turn of speed, that Sr. Baris. I suppose it's a talent you're born with.'

'And the very best of luck in *la grande boucle*, Signor Azafrán.' They pushed him off smoothly, entered the back seat of the car together, slammed the doors as one, and the uniformed driver took off in pursuit of Ettore, revving the car to a maximum in every gear.

Stage 13

In the first week of that year's Tour de France the yellow jersey switched five times. Carabuchi, Tiss, Gestalt, Mejillones-Hervidos, Peluso, all on different teams, young guys in their third or fourth years as professionals who had found their strength, they didn't let an important break go between Stuttgart and Aix-les-Bains. Such was the never relenting speed and the fierceness of the competition that nineteen riders had to drop out exhausted.

Sáenz and Baris were each other's shadows that week. Akil, whose granddad probably used to kill priests with a rock if he found them wandering alone, would make sure he was near Ettore as the riders gathered for the start, and he'd bow his head to Msr. Blériot's prayers which, since the Giro, had become even fiercer, and accompanied by big combustions of incense. The holy smoke brought another protest from the ever protestant Aussies and Yanks, who seemed to think that a particulate burden to the environment of over one part per million might stuff all their filters.

Once racing started Akil and Ettore rode together somewhere near the front of the peloton. When there was a break which included one or more danger men, they went and sat on the back of it and thought their own thoughts.

It was clear that neither of them was under much strain. All around them the young Turks rode their hearts out for twenty seconds at the front here, fifty there, while the commandantes swept along at the mean speed of the tête de la course, legs like con. rods powered by the same huge flywheel spinning at an invariant 110 rpm.

They had the rhythm of migrating geese. This Norwegian, one time he imprinted a gosling on his Ford Transit van. Then he'd drive along the runway with the goose flying beside him. What he discovered was that when a goose accelerates, it's wings don't flap any faster. The bird keeps the same cadence but it takes in another notch on the pinions, it drives up the

pitch and the torque and thus the speed without the slightest change of effort you can see – though you can bet its heart rate tells a different story.

Just this was demonstrated by the Sáenz/Baris duo on the Lac de Madine to Besançon stage, 225 kilometres of up and down with first the Vosges and then the Juras on your left, no desperate climbs, but taxing nonetheless.

At one hundred kilometres Tiss made a lone break. Guys do this sometimes for no good reason but their legs are feeling twitchy, their spirits are high, it is a nice morning and it seems like a good idea at the time.

When Tiss disappeared up the road, Akil and Ettore didn't budge. Neither did anybody else. Riders can make stupendous lone pilgrimages, be away for a couple of hundred kilometres, and the bunch will bring them back five hundred metres from the line. On the flat, the bunch is a TVG running down a buggy. It takes it's time to get going, but once it has momentum it doesn't falter. So though Tiss was a strong man nobody was going to lead a bridge across to him at the moment. Let someone else sacrifice their strength.

With fifty kilometres to go, Tiss was four minutes forty three seconds clear. The front of the bunch began to put the pressure on. Then there was a small incident. Madrigal de los Torres, a smarmy fatlipped fuck as despised for his bragging as his father had been admired for his selfless determination, was trying to adjust his glossy black *mata de pelo* in a shop window as they passed through a small village, and touched the wheel of another rider. Nobody came off, but there was a bit of braking and swerving and a whole lot of swearing, and in the seconds it took to sort it out a break of nine had gone clear, including Narabellini and the rest. It so happened that Akil and Ettore, side by side as always, missed the break. They were now both in the danger zone, left stranded while the nine best riders from the next generation powered into the future.

Patrul Azafrán went from the front to the back of the peloton like a herald, calling for a counter attack. But Cosimo had Eco in the break, and QiK had Perec. This was strictly speaking irrelevant since neither of these riders had a hope in hell

86

of taking the yellow jersey, let alone keeping it through the next two weeks, but it gave the guys an excuse for laziness – that sort of insolent laziness the young show, as if they might make an effort, but the choice was theirs. Patrul wished that senior équipiers could be supplied with a whip, like galley masters, but knew this was not in the spirit of modern thinking on personnel management. Just as well there were some young riders in unknown teams who were spurred on by Azafrán's shouted encouragements and eager for a bit of TV coverage, and in five minutes he'd got the bunch up to a peak of a blistering fifty two or three kph, and shamed the QiK and Cosimo boys into taking up the front and riding.

At thirty kilometres the bunch was eating into the gap to the leading group, and all looked well. But at fifteen, word came through that it was not fast enough, that the leaders would hit the finish line with a two minute lead.

Patrul talked over the possibilities with Akil in Ettore's hearing. Two minutes wasn't fatal to his chances of winning in Paris, but it was an inconvenience, a weight around the neck.

There, at a speed already of fifty kph, there was a moment of quiet reflection. Ettore bowed his head and crossed himself. Then, at no signal, no indication of agreement, they screwed down the pitch a couple of notches more on the back cassette, wound up the torque and, like migrating geese tensing the pinions a little tighter against the air, without the slightest change of effort being perceptible to the onlooker, even an onlooker right on the wheel and as experienced as Azafrán, they hit the wind a bunch of watts harder yet.

Patrul tried to go with them. Unable to match their deep strength he span his legs faster, till his heart was jolting like a copulating mouse against his clamorous lungs – this, one of the strongest riders in the world. He looked at his patron and at Baris, and they were still breathing through their noses. Fuck that for a lark, thought the great Azafrán, sat up on the tops and waited for the bunch.

Sáenz and Baris worked together like lazy supermen. Roadside spectators were reported in the press as hearing a different, unusual note to the sound of their passing – nothing

mystic, just that all the harmonics of man and machine in motion were tuned up a semi-tone above the natural. Sáenz would lead for a hundred metres, then Baris, and they changed with a rhythm that suggested they were almost inside each other's heads.

Riders who arrive at the finishing line within a few bike lengths of each other are all given the same time, for practical reasons if you think of sorting out twenty or thirty arriving in a mêlée. Now, as the leaders came into the last straight, Akil and Ettore were still twenty metres adrift. But there was no feeling of fluster, of panic, of wasted energy. They continued with the rhythm of migrating geese.

Peluso, who has no burst of speed, lead out for his team mate Vanderiver. The rest, already jostling for position over the previous kilometre, exploded into the sprint.

Two mortals should never have been able to make up the twenty metres on such a headlong group. The gap should have been unclosable. And yet ten riders finished at 'all same time'. Vanderiver won the stage, followed by a small and angry swarm of multicoloured devils, out of the saddle, legs a-blur, bodies, frames, wheels thrashing and weaving – and it seemed above them, like quiet eagles, Baris and Sáenz, relaxed, aerodynamic, turning enormous gears, stooped to the finish; the photo shows the arcs where their front tyres, precisely superimposed, kiss Peluso's back wheel vertically above the line.

Such was their terminal velocity that they split right and left round the gaggle of sprinters, and even shot past Vanderiver twenty metres on with his hands still high in victory salute. This accuracy, so far in excess of what is normally called a 'well-judged race', makes the hair stand up on the nape of the neck.

*

What of Akil's state of mind at this time? Patrul worked as always to keep his patron in a positive mood. After all, there was nothing to be depressed about. Akil arrived at the Alps fourth over all, a minute and a quarter down on the leader, Tiss. This was just the kind of thing you aim for, being in easy

striking distance, but not provoking the constant attack that wearing the yellow jersey invites. And he had shown by the ride into Besançon that he had frightening reserves. The lead group had been swept up like leaves.

But what was true of Sáenz was almost exactly true of Baris. The only variation was in the sprints along the way. Side by side, sometimes one had been credited with bonus seconds, sometimes the other. They arrived at the Alps with Baris one second ahead of Akil.

'What the fuck's going on?' Patrul asked him when they had retired to their room after the evening meal and the team meeting during which Akil had, as had become his habit, refused to discuss any tactics at all, giving the rest to understand that they were irrelevant.

'I shall be riding with my substance,' by which he meant Baris. Akil had developed the 'joke' that Baris was the substance, and he Akil was the shadow. Now, sitting up in the bed, propped by pillows, he explained to his friend how this was such a good idea.

'You see Patrul, I have been giving a lot of thought to this problem. I can see that you act as if it is nonsense, this thought of mine that I am merely part of the plan, and you are all in on the plan, but I am excluded, for amusement. You think it's garbage, but I see no way of dealing with this logical knot – which I have explained to you before . . .'

'Akil, my friend, if logic ties the world in a knot, then cut the knot.'

'That's it, that's it exactly. If you are in on the plan, that's *exactly* what you would say. I could have written your lines for you in advance. I mean – with something as huge as this, that you are all in it together, you'd expect there to be some big obvious proof that it is not so. But I can find no such proof.'

'Fuck me Akil. You know very well you can't prove something isn't true.'

He thought for a bit about this. 'That's just what you're told to say – but in this case it's an obvious lie. A person cannot be in two places at once. You Patrul Azafrán are here.

Therefore you cannot be in Siberia. There, I've proved you are *not* in a certain place.'

'No. Where's the proof that someone can't be in two places at once?'

Akil looked a bit angry. 'By definition. By definition a person cannot be in two places at once. The definition of a person is someone who is only in one place at a time.' He glared at Patrul, his eyes glowing, his nostrils flared.

When Sáenz gets into this mood there's no point in arguing. Patrul just asked, 'Anyway, what were you going to tell me?'

'About my solution. This is only a way of saying it by the way. I'm not mad. That is to say I'm not loony. I'm not loco.' He turned to Patrul where he was sitting on the end of the other bed, leaning against the wall, his knees under his chin, and Akil pulled the craziest face ever, like the flip from archangel to devil. His cheeks and lips writhed, his snout furrowed, one eyeball stood out like china and the other jerked beneath a wet wrinkled slit. It was so horrible it made Patrul jump. Akil laughed, a sane, jolly laugh, quite unusual for him these days, and then his face returned to its habitual gravity. 'No, not mad. But for my own peace of mind I have decided to become Ettore Baris's shadow. What is a shadow? Merely a hard edged lessening of the light. It has no responsibilities, no will. It cannot be part of the plan. Only the thing which casts the shadow can be that. Baris is down to win the Tour, just like he did the Giro. He pretends it's God, he has been given a priest as a prop, but if he wants to call the plan God, fair enough by me. I know what he's talking about. I have become his shadow. In this way I can lose no more.'

'Lose no more what?'

'Races. Myself. No more.'

Patrul tried to make a joke of it. 'But what of the days when there is no sun?'

'So far I've been lucky. The sun has shone on every stage.' Then he laughed. 'No Patrul – you never were very subtle were you – not a light shadow. A spiritual shadow. Look at me. Do I look two dimensional?' He held out his hand. 'Is this

grey? Does it slide over the wall like water? Gimme a break. Don't patronise me.'

'But my friend,' implored Patrul, beginning to be genuinely upset, 'it was you who talked about light, shadow being – just less light, two dimensional as far as I remember. So you can't blame me for thinking that's what you were talking about.'

'Either you are stupid,' said Akil to his friend, 'or you are playing dumb because that's the part you've been given for tonight. Either way, I can't be bothered with you. Just watch, and you'll see.' He slid down the bed, turned to the wall and pulled the covers up around his ears.

Many riders fret and worry during a big race, and sleep little and badly. Akil Sáenz wasn't one of them.

Patrul Azafrán was.

Stage 14

This edition of the Tour de France, the one which started with Sáenz and Baris doing the migrating geese bit, is made up of a prologue, twenty one stages, one rest day, and it covers about four thousand kilometres.

The first week is flat with just a few little bumps, and the serious argy-bargy is among the sprinters fighting out the points prize for the green jersey.

The second week climbs the Alps, descends to the valley of the Rhone and climbs once more into the Massif Central. As the race leaves the Alps there is a time trial up the much feared Mont Ventoux.

The third week traverses the valley of the Garonne into and along the Pyrenees, then goes up the coast through Bordeaux to Paris. The rider who does the lot in the shortest time gets to keep the Yellow Jersey.

<p align="center">*</p>

Mount Ventoux is something you notice, even in a mountainous region. The stuff at the top, it's like the white clay they used for the elements of old gas fires. Perhaps that's why they call Ventoux a furnace. On the lower slopes you climb through forest and green shade, but once you move out into the glare of the shale you know this white mineral, if they suddenly extinguished the sun, the top of the mountain would still be glowing dull red. The pine scent and the bees are far below in the haze. Here the road ramps up through pure heat. When Tommy Simpson died here he was so full of amphetamines that his body couldn't save itself by switching off. He lay beside his bicycle three-quarters dead, and his legs would keep on turning. Completing the stage. Mortality. That's cycling.

Akil had secretly changed his mind. On Ventoux he would become the substance once more. He would cease to be Baris's shadow. He would show the world that he was beyond

their plan for him. He would ride like the Sáenz of old, unvanquishably. He would push his body so far that even if Baris was taking drugs, the dope would be as nothing to Sáenz's will – and if his body died in the attempt, that would be the place to die.

The day before the Ventoux time trial was a rest day. Even in a three week stage race, you don't stay in bed on the rest day, or by the day after your legs might have seized solid. You go for a spin. Sáenz decided to go for a spin up the mountain.

Patrul offered to go too. He was glad when Akil said no.

How Fleischman knew to intercept him there – that nobody can say. Perhaps he had contacted Akil beforehand. Perhaps he had a spy, though who? Not Escoto. Not Azafrán.

Less than a kilometre below the summit of Ventoux with its café and ugly scientific buildings is a little shrine, heaped up among the shale, to the dead Englishman Tommy.

Of their nature cyclists do not come from the richest segment of humanity. There is too little dignity in it, you have to use your own body. This shrine had old and poor things laid there – dried flowers, worn out track mitts and shoes, post cards. It had the tatty strength of genuine superstition. Many have been surprised there by their own tears.

It was there that Akil Sáenz got off his bike on the rest day and with his back to the road knelt in something like prayer. It was there that Mikkel Fleischman, gliding down from the summit, brought his car to rest and went and stood behind the kneeling figure and laid a hand on his shoulder. Sáenz, who had been very alone, for a moment laid his head to one side, his cheek against the doctor's knuckles. Mikkel for that moment felt he had achieved all the world had to offer.

Then Akil got up, stood like the god he was and glared down at Fleischman, his eyelashes wet with tears. Fleischman moved from triumph to humility. His face had that slight collapse of vulnerable pleading which makes the most beautiful ugly, and Fleischman wasn't beautiful. When someone looks at you like that, you have to love them back very much not to feel a shiver of contempt.

Perhaps it was a puff of breeze on the cooling sweat. Akil

turned away and hobbled down to the road. Without discussion he got into the passenger seat of the blood red Maserati. Fleischman followed him, started the engine and began to turn the big car in the road. An Audi with Swiss plates came to an exaggerated halt and hooted, the driver waving a fist and shouting, the wife looking stony faced, the kids blocked out by their personal stereos. The Swiss had in his Audi up to that moment been making superb time up the mountain, and his rage was justified.

Akil turned his head to look, and the man suddenly recognised him. His hysteria changed its object, and he was scrabbling in the glove box, lurching out of the car with book and pen, leaning with one hand on the roof, tapping at the window for the signature of the idol acquired, you know, on Mt. Ventoux, just beside the memorial, what a story back home in Helvetia. . . his face was close to the glass with a stupid smile on it when Fleischman put his foot hard on the accelerator and let in the clutch.

The Swiss stared open mouthed up the road after the scarlet car. He shouted obscenities for twenty seconds. This act contrasted piquantly with the hugeness of the sterile scree behind him, the pathos of the shrine. Then he rushed to his own car, emitting a sort of long screaming growl. His children held their personal stereos harder to their ears. He took off in pursuit of the Maserati. He caught it on the last bend, but by that time his wife must have explained that whatever course of action he took next, he could only make a bigger fool of himself, and even that might not be possible. So instead he swung off into the café car park, scattering a family of English tourists as he taxied in as if they had been the object of his righteous fury all along.

Fleischman meanwhile continued past the scientific buildings and another few hundred metres to the north-eastern bluff, ran his car up on the side of a culvert where it was absolutely forbidden to park, and led Akil over the edge to a fine gravel bank.

What a pair! The smallish man in slacks and short-sleeved shirt, his skin the gentle milk and honey of the summer

Scandinavian, a Cosimo casquette on his fine curls to keep the burning sun off his face, his eyes self-consciously merry behind his wire-frame specs. And the bigger guy, in black lycra shorts and a QiK jersey, unzipped at the neck, his skin as dark as oiled cinnamon, the hard curls of his hair like bronze swarf, the veins running above the muscles of his legs, displaced by the graceful swelling.

They sat down, a metre or so of clear space between them. Akil looked steadily to the northward, the subtle mauve of his eyes washed out to dried lavender in that tremendous light, and waited for the other to speak. But Fleischman was silent, so in the end Akil said, 'I am supping with the enemy,' as a sort of half question, half regret.

Fleischman laughed. 'Do you mean Cosimo's directeur sportif, or do you mean the devil? For the first, we could be discussing contracts. It is time you were deciding your plans for next year.'

'And for the second?' murmured Sáenz.

Like cut-outs of anodised aluminium ranked back across a stage so that they seemed to rise through ever deeper light to the impossible distance of the cyclorama, the Alps lay at their feet. 'All this can be thine.'

'It already is,' said Sáenz.

'There is the added complication . . .'

'It happens,' said Sáenz. 'I'm not one of those guys who gets violent about it. On the other hand I wouldn't let it cloud your judgement.'

'I'll do my best.'

'So what's the deal?' Akil asked.

Fleischman turned and smiled at him an easy, natural smile. 'I want your soul.'

Akil smiled back. 'No, I mean the other thing, the contract for next year.'

'It is a contract, and for a year. Don't you know? Mephistopheles gave Faustus everything he wanted for a year, and then he came for his soul. Of course we don't have souls any more. But I shall come for you after a year.'

'Is that what happened to the others?'

96

'In a way, yes.'

'And Baris?'

'Probably not. See, I'm only an apprentice Mephistopheles – that's science for you, always learning your way. But with Baris we seem to have got it about right. He's become extraordinarily pious, sure, but there is no sign of any physical degeneration of the brain. It often happens with postnatal depression, religion does, and it's reversible.'

'Ettore had a baby?'

'No, I mean there's something in the metabolism which is causing his chronic holiness, but it's not a result of any cellular modification, so . . .' He smiled reassuringly. 'Also we don't want to give the police cause for concern – another violent murder in the cycling world would embarrass them. Oh, I think Ettore's safe, as long as he doesn't get too much holier than he is now, and continues to walk straight, yeah, he's got many more years of life.'

'And he'll go on riding?'

Fleischman shook his head matter of factly. 'No, he's done his bit. He'll move on. We need his place. We're moving to the climax.'

'Cosimo?'

Mikkel waved the question away. 'Let's talk about important things.' He turned and pointed behind his left shoulder at Mont Ste Victoire rising like a limpet through the haze. 'That's what humans can do.'

Akil too turned to look at the distant mark. 'I thought nature did that – long time before we were here.'

'No, nature piled up the rock – geology formed itself – but Cézanne made the mountain. When the last human dies – no more Mont Ste Victoire. Finito.'

'I'm not interested in philosophy,' said Akil. 'Philosophy doesn't win races.'

'It's not philosophy, it's true. Each of our deaths impoverishes the universe, not us.'

'Look,' said Akil, 'if you're just going to sit there talking bollocks, I'll be on my way. I've got a time trial tomorrow.'

'Señor Sáenz, what is life? No, no, I'm getting down to

practicalities. Life is constant flight from the banal, for most people an impossible journey. It seems to be an impossible journey.'

'I want to beat Baris.'

'That's it, is it? Beat Baris. I want to beat Baris. That is the end of your ambition?'

'I'm just an animal at heart,' said Sáenz.

'You know, I look at humans, and my skin crawls.'

'Mephistopheles.'

'Yeah, if you like. I have brought you up to this high place.'

'No, I came most of the way on my bike.'

'I have brought you up to this high place to offer you all you can dream of – if you bother to dream properly. First, to my supernatural powers. You will lose the time trial to Baris tomorrow by around nine seconds – whatever time you do it in, and you are right to do it fast, because then Baris will be in yellow. In the Pyrenees QiK will of course attack and Cosimo defend, but you will make no impact on his lead. Then on that last huge day, 260 kilometres and five cols, two *hors categorie*, you will go away together, as if you had been taken up into the clouds, and the race of men will go on without you. You will arrive in Ascain getting on for an hour ahead of the rest – that will be my reward to Baris. But *you* will have done it on your own, without my help – and what is more you will make up the nine seconds on bonus sprints, and a few seconds more. You will both arrive for the Hour in Bordeaux on exactly the same time, but with you in yellow on points. On the track you and Ettore will travel for fifty five minutes as if you were painted on opposite sides of a spinning top – so silly – and then in the last five minutes Ettore will roll up the space between you. In the last second of the last lap he will be by your side. You will nearly die of disappointment and shame. Ettore, my Ettore, will ride into Paris with a lead of around 7.5 seconds. He will win the Tour de France. Nothing we agree today will alter that.'

'You're serious – and if I go to the police?'

'That Gabriela Gomelez, she may be only a low rank cop from a one-horse town in the sticks of Andalucia, but she

seems to have a feel for the case. Why's she faded into the scenery?'

'She came to see you?'

'That was her job. We had a nice time together. She looked round my lab, saw through the charade, we joked about it. We have certain things in common. If I'd thought the thing was going to be left in her hands I might have become a little anxious.'

'But me, I have a voice. I can confirm what she suspects.'

Fleischman, when he shook his head at Akil with a gentle smile, his concern was genuine. 'People are already whispering about paranoia. Even your friends. You see, if you look around you, there's an awful lot the police aren't really interested in. I don't know, I'm not a policeman, but what they're interested in is things that don't *fit in*, if you have a feel for what I mean.'

'And killing professional cyclists fits in OK?'

'I don't think they have any means of knowing at the moment. I'll tell you something, Akil. I don't want to get old. I know it's considered a bit uncharitable, but I detest old people. The human mind when it becomes absorbed in itself is the most disgusting receptacle . . .'

'Sure, but as I say I have a time trial to ride tomorrow.'

'. . . which means that I have no interest in extending my days. It's a bizarre fallacy – that time leads somewhere. It must come from the fact that mankind has achieved wonders of civilisation over the last ten thousand years, leading to a notion of indefinite continuity. Do you know why it has only been in the last ten thousand years that civilisation has occurred?'

'Something to do with time?'

'No, the weather. The weather's been good. But we're a very flexible species. Come the next cataclysm, ice from pole to pole, just a dry ravine round the equator with a humid fringe of green swamp, and no wind, and silence – still a few of us may survive, sheltering in the warm mud. And in five or fifty thousand years, when the ice melts again, their few hundreds of descendants will go forth and multiply, and find

ancient stones piled one upon another, and decide there were once heroes and gods. But I know, you have a time trial to ride.'

'So what's the deal?' asks Akil, 'because my legs are getting stiff.'

'I could massage them.'

'No thanks,' says Akil.

'I would be interested to massage your legs from a professional point of view. After all, they are the best in the world. Lie back.'

'Better than Baris's?'

'Of course better than Baris's.'

'OK,' says Akil, and Fleischman began to squeeze every bit of stiffness and pain from the muscles that had already driven a bicycle over 2500 kilometres in the previous twelve days.

He worked for a while in silence. Then he said, like he was giving some scientific information, 'Life is not a process of accumulation. It starts, it stops. In the last second, all you have is your own corpse. It doesn't make the slightest difference when the last second is. Time is dust, Akil Sáenz. You know that, and that's why you made your decision long ago, when you became a bike rider. You're just waiting for your proper moment.'

'When you've finished the other leg, I'm going,' said Akil, 'and anyway, what about a good time, a time sitting with your friends, la sobremesa, with a bottle or two of wine, the hake and garlic in your belly, laughing even, like the good times, they used to be, before you murdered Jan Potocki.'

Mikkel Fleischman sat back on his haunches. The sun was getting too hot, and he was sweating. Behind him the Alps rose in pastel planes through the heavy confusion of light to the very distant edge of the sky. He turned to the other leg. 'You have those things too – as did Jan. What I will make is something outstanding, something beyond the future's ability to exceed. That'll show time, that will. I will make Akil Sáenz the greatest cyclist there will ever be. With his approval, of course.'

'And at the end you come for my soul.'

100

'Not necessarily. Not if things go right. Though in a way it does seem better. Tragedies last better.'

'But you're not interested in time.'

'It's a paradox, isn't it. I never said things would be perfect.'

The doctor worked on, while Akil seemed to sleep. Then he suddenly sat up. 'What does it involve? I mean, what's the trick?'

Mikkel smiled, and winked.

'But it's safe?'

Mikkel rocked his head ironically.

'I mean,' Akil said quickly, because he never liked to seem a fool, 'safer than it was with Potocki, with Sarpedón.'

'Perhaps even safer than with Ettore.'

'You undertake I shan't be infected with religious mania?'

'That's half the fun of it. I can guarantee nothing about your state of mind. As I say there are those who say you're a bit touched already. What I can guarantee is that if next year you win the Giro, the Tour and the Worlds, and get the hour by an unreachable margin, nobody will ever refer to your state of mind again. But that's not what it's about, Akil. What it's about is, there will be an area of human achievement where you and I together will be immortal.'

'Bike racing!' said Akil.

'Yes, that's it. Bike racing. That's what you do, Señor Sáenz.'

'You don't want an answer now?'

'The sooner the better. There, your legs are finished. They are perfect.' He got up smiling, helped Akil to his feet in his awkward plated shoes and they went back to the car.

As they cruised down the long straight through pale volcanic shale to the Tommy Simpson memorial, they both tensed. An Audi was already parked there.

The shrine robber is not admired even by the secular, certainly when the shrine is poor, as this one, way up among the sterile mineral landscape, very small and desolate, the cyclist climbing the steep hill to death.

Akil had left his bike by the memorial. Such a relic with the authentic Sáenz painted in small neat freehand on the top

101

tube should have been inviolable. However, the Swiss had just put this bike into the boot of his car.

There was a line of cars coming up the other way, so Mikkel couldn't cut him off. The thief, gloating on such a prize, half triumphant and half sick with fear and shame, took off with a yelp of rubber down the mountain. Fleischman, adrenalin spurting into his blood, spun smoking wheels behind him.

At the tight bends it was hairy stuff. The old Maserati had twice the engine size of the Audi, but little more power and none of the handling. In a way this was an advantage. Mikkel could feel and hear where he was by the scrabble and howl of the tyres and the hysterical growl of the exhaust, while the Swiss in his Germanic refinement could feel only the lurch and swerve of gravity, could hear only the shrieking of his dear family.

It was an uneven contest. On the second or third bend Mikkel drew level with the Audi, but there was a motorbike coming fast the other way and he had to pull back. However the Swiss was by now entirely uncoordinated by fear and the blows of his wife, braking and accelerating and sawing the wheel with too little regard for the objective conditions of the highway. Fleischman came through a bend with the back smoothly adrift and in one surge went by him, stayed on the outside and when he saw a small lay-by on the right, forced the Audi almost willingly into it.

Even now the Swiss was not prepared to acknowledge his crime. He stood against the door of his German car, his sweat soaked shirt glued to his body. He was quite a big man, bald but still with a rim of dark hair, and he was not afraid to glare at the slight, crazily smiling auto-criminal emerging from the far side of the red Italian machine. He didn't much fear the world-famous cyclist climbing lazily out this side either. His blood was up. His driving skills had been belittled.

'You crazy pig,' he started. 'You make danger to me and my family and my auto, I will have you locked up. You accompany me now.' Then he seemed to suddenly remember the stolen bike in his boot; the police would not be the best

solution. ' I am an ordinary man enjoying a vacation with his family. This time we forget it, but next time, your guts for garters, eh?'

Mikkel leaned pleasantly forward with his hands on the Maserati roof. 'Just give the bike back.'

'Bike, what bike? Are you crazy?'

'Just open the boot.'

'Look, the cars are coming past, they see you, they see you trying to make robbery. If I cry for help, you will be locked up. Robbers.'

Fleischman could do a thing with his face, the smile slid off the bottom of the screen, leaving it cold.

The Swiss thought about the immediate future. Then by shrinking a little inwards he peeled himself off the front of Fleischman's stare, walked round to the boot and opened it, lifted the bike and carefully propped it against a tree, got in his car, and departed.

The victor touched Akil on the shoulder. 'You must ride.'

Stage 15

The rest of the Tour turned out as Fleischman had predicted. Akil, second to last off up Ventoux, beat the course record by nearly two minutes, but by the end of the day was still seven seconds down on Baris. That was no mystery. Baris was getting time checks all the way up. He was the leader. He was riding within himself.

Their lone break over the Pyrenees has been written up a thousand times, and there is a three hour video. The commentators make it sound like they rode to the moon, but again there is no real mystery. Not to take anything away from either man, there have been lone breaks before, conventionally by one man riding on his own. Once Sáenz and Baris had attacked as substance and shadow on the Marie Blanc, and Peluso the pure climber, and Gestalt, and Frangipani who is another brilliant climber on his day who can also go like a torpedo in the *contre le montre*, and Menaleon, still with QiK though god knows why but today having one of his rare days of riding like a man, and Carabuchi, perhaps the all round strongest of the young upstarts; Harta-Ruin, the oldest, most drug-raddled, honest, generous fellow in the bunch; and of course Azafrán, as always full of energy and cunning to do his master some service; once they had attacked on the third col, and one by one blown up, fallen away exhausted like leaves in autumn, the last to go, Peluso, standing on the big ring in tears and with a horrid clang of graunched gears coming to a complete halt; once that had happened, and the two went on alone as if under the road like the devil up and down the mountains rolled a massive flywheel articulated by invisible couplings to the flashing knife blades of their spokes, the eternal whip, whip, whip of their tyres, the tireless rhythm of their legs; there was nothing so surprising about it. The two best riders of their era got away from the group on the hardest stage of the tour, crossed five mountain passes, rode the distance from Paris to Brussels, Amsterdam to Bonn, but you've got to go

over the Himalaya Kulhakangri in between, that's the literal distance travelled, the height climbed, and came down into Ascain like a whirlwind.

It is not surprising that once they had escaped they should build up a lead of almost an hour. The morale of the peloton had gone. What was there left to fight for? All the guys in the gold and all the guys in the silver, QiK and Cosimo, worked together for once at the front, across the road three deep and back, hands on the tops, keeping the speed high enough to discourage further attacks, but not so high as to eat into the time gap. Peluso had already won the polka-dot jersey. The bucket was empty. It was the first and only time, except to honour a death, that the whole Tour has gone across the mountains in the bus.

Fleischman had calculated the mountain primes where Baris should defer to Sáenz even more precisely than he had predicted on Ventoux. When they arrived in Bordeaux for the hour time trial on the track, Akil was in yellow by eight point seven five seconds. When they left, Baris was in yellow by less than two.

This final time trial, it's an innovation, a place of weird machines. If you were a spectator on one of the mountain passes today, the super-light bikes would be little different in appearance from the machines of years ago, pedalled by earlier heroes, Coppi, Anquetil, Merckx, Hinault, LeMond, Roche. They would look like the bikes our dads rode when we were kids.

But the Tour is a commercial race, and innovation must be given its place on the catwalk, or in this case the vélodrome of Bordeaux. The new track machines are far from minimal. The riders come out, knights for the tournament, neck to thigh in slippery lycra with the sheen of deep space condoms, faired helmets on their heads like the glans from another galaxy and neoprene pixyboots to slide the air around their feet, mounted on gaudily caparisoned donkeys – the carbon fibre monocoque monoblade. Gone the slightness of metal; in its place, a coloured plastic slab. A beautiful and rational slab, no doubt, but something uncompromisingly solid.

Which is right of course. To cover fifty five kilometres plus in sixty minutes, what you need is as narrow and perfect an ellipse edging the wind as technology can devise.

Just the top twenty on aggregated time by the end of the third-to-last day of the Tour were to fight it out round the track in paired pursuits and over the hour. A kilometre equalled one minute of time lost or gained. The organisers have come in for a lot of stick over it, but as the Société du Tour de France point out, it is a discipline of the utmost equality. There is no wind, no rain, no potholes, no jostling spectators. Just an oval track as smooth as a lark's egg, the humidity of an Atlantic city in July, and twenty exhausted men.

Safe there, the ride into Paris is a triumphal march.

As with many scientific tests of endurance, it promised to be an event of mesmerising tedium. That's fine for those concerned with eternity. Luckily the mortals livened it up. Tiss and Carabuchi managed to have a fight sprawling on the track, flailing at each other with outstretched arms with their feet still bolted to their shattered cycles – a result of Carabuchi riding too triumphantly near his rival as he half lapped him, bringing them both down in a shower of shattered plastic monocoque and thousand dollar wheels. For disgraceful brawling they were both docked ten minutes, and moved from third and fourth to seventeenth and eighteenth. This started sympathetic fighting in the crowd, and fire hoses had to be used. The discipline was a huge success.

As for the battle between Sáenz and Baris, in the last five minutes Ettore had rolled up the space between them. In five minutes he had gained exactly ten seconds, and was now one point two five ahead on aggregate. It was by that amount that Akil lost the Tour de France that year. A half a millionth of the time they had been in the saddle, more or less. As Akil rolled to a halt and into the arms of Escoto, Fleischman stood at Baris's shoulder while his soigneur supported the victorious rider. Fleischman was tapping figures into a calculator. His eyes met Akil's and he winked.

★

The sun had set behind the mountain. Venus was shining so bright to the south that you could almost hear the sound, a flawless chime of ceaseless crystal, and the brighter stars were beginning to spark and glow. It was between the summer and the ski season, and the road had not seen a car for the last hour.

The two men, one robed, the other in only a loincloth, worked together. From the little platform of the memorial they had cleared a space among the offerings, and dug a hole. The end of the upright timber they lodged between four irregular boulders of volcanic pumice, then packed fine shale around it, wedging in four more boulders at the surface.

The cross-halving and stout hardwood dowels had already been prepared, and the crosspiece clunked home with just two blows of the mallet. The half naked man now stood on an aluminium step ladder and bound the two baulks together with strips of goatskin. Then he turned and prayed in a huge hollow voice, stretching his arms along the horizontal beam. His prayers seemed to roll down the scree and fill the sky that went back nearly to the beginning of time. When he was again silent the robed man too mounted the stepladder and standing against the half naked one like a lover, leaned out and bound one hand and then the other at full stretch of the arm with strips of hide that bit into the flesh. Then he went down again, reached up and guided one sinewy vein-ribbed foot from the metal platform to the half-step, set it there and picked up a mallet and a spike, needle sharp at the tip, thickening to nearly two centimetres square.

The gloaming was green gold and clear as space, but the light was almost gone and the priest short-sighted. He worked mainly by feel. He put the point between the first and second toe, and slid it up between the tendons until it came to ungiving bone. Just below that place was a slight hollow. With sure blows of the mallet he drove the spike into the hollow and through into the timber until only a few

centimetres remained. Then he guided the other foot to the half step. The man above him made no sound but for the blown expulsion of his deep breaths. Black trickles dripped between the toes

All went as planned. The self-sacrifice was secure. There was no danger that when the underpinning gave way, the arms would slip from the thongs. The grooves around the wood made sure of that.

The priest hurled the stepladder from the memorial down towards the road with a brief clatter and in the then stillness dropped to his knees, the head forced hard back so the face was offered to the glimmering figure above. For quarter of an hour he prayed in terrible lamentations. Then he was silent.

In the sixth hour up on the cross the legs that had till then been tireless began to buckle, first alternately and then together. As the weight hung more and more heavy on the arms the ribs depressed, stretching the thorax until the diaphragm was suspended by a frame as inflexible as steel. Ettore Baris, who in life had breathed more deep and easy than most, forgot his grace, and began to struggle and make noises like a mortal. But Fr. Blériot did not move a muscle through all those long minutes, until his lord was still again.

<div align="center">*</div>

. . . that I Ettore Baris in the name of Christ, not claiming that I am Christ, but that if the Son of Man chose so to be of the flesh as of the spirit, and if the flesh of me, Ettore Baris, has been viley transfigured by the sins of Sodom but to triumph together with the spirit to win merely the World's pride, then as Christ did before me to transfigure that flesh once more by suffering, in His image, the representation of His despair, only to rise again, to that I freely, intentionally and wholly give myself,

 signed: Ettore Baris
 World Champion

Witnesses signatures hereto: Fr. Bernard Blériot
 Vincento Carabuchi

As the examining magistrate said, it was bollocks, but it was a valid document. Carabuchi agreed he'd witnessed Baris's signature on the morning of the World Championship. He hadn't read the ten page 'confession' as he had other things on his mind, mainly the race that had been due to start in a couple of hours' time. But Ettore had been, as always then, serene, friendly, detached, so incidentally confident – the race, oh yes, that is not a problem – that the closeness of his win had seemed almost a fault in nature.

With three kilometres to go he had upped the pace of the lead group to break the sprinters, and then at two he'd upped it some more and opened a gap of a hundred metres. However Sáenz, Azafrán and Tiss chased, working selflessly together, even the young Plute rider, and when Baris crossed the line they were closing a ten metre gap like a spring. With any other rider one would say that Ettore had timed his ride to perfection – but signs of mortality were suddenly in his frame. Once over the line he slumped into the supporting arms of Fleischman, his priest and his mechanic, and had to be helped from his bike and half supported away. On the podium his face was no longer radiant, the nose emphatic and beaky, the cheeks grooved with exhaustion.

There was never any suspicion of foul play in the World Champion's crucifixion. For the devout, it was a big advance on giving the *maillot jaune* to the Pope. The Tommy Simpson memorial had been transformed by Baris's death from a shrine to the suffering of cycling to – *per saecula saeculorum* – a remote terminal of the Church of Rome. Miracles were expected.

A more secular examination decided that Fr. Blériot was mad, and unfit to stand trial. Despite Ettore's 'confession' the priest was convinced that the World Champion *was* the Son of God and he Blériot the Baptist. He spent the rest of his years in the Charterhouse which otherwise would have received Baris, watched over by Rome, waiting for his risen God and *campionissimo* to appear in his power and his glory.

There was no question that the crucifixion, out of the

ordinary maybe, should be linked to the deaths of Potocki, Sarpedón, Agaxov. Mikkel Fleischman in particular was devastated by it. Baris was to have been his demonstration, to Akil Sáenz as much as to the world, that under his protection a rider could be great, and live.

Stage 16

So the dead part of that year came and went.

No good had come of anything yet, and Sáenz leaving QiK and going to Cosimo, why should any come of that? That's what Azafrán thought, and nobody ever said Azafrán was confused by events. Even so, a few months on, those early Spring Classics felt deceitfully like the best of times.

Akil had signed up with Cosimo even before Baris's crucifixion the previous year, taking Patrul Azafrán and the first year professional Jacobi with him. In December he'd gone into purdah with Mikkel Fleischman, who had told the now swelling Perlita to go home and concentrate on being pregnant. Akil asked Patrul to look after her, which, like a brother because of her condition, he did, also removing key bits from the Diablo in case she should have sudden unmaternal urges.

Patrul teased Akil a bit about Fleischman before Akil set off for Siena. Akil had taken Patrul's teasing badly. There was something there that Patrul didn't understand, didn't know about. The silent given was, Akil was entering into a heavy, secret programme of training with something extra done to the body, something added or modified, not in the usual sense drugs, something more advanced and less clean; this Patrul would never joke about because of the shame; but flirtation, Akil had never been sensitive about flirtation before. Perhaps it was because the gossip round the peloton muttered that the fathering of Perlita's unborn was a two up break.

When they met again at the training camp in the south in February, whatever the fuck it was Fleischman had been up to with Akil it was doing him lots of good as seen from the outside. He looked more than ever like a titan out of a well drawn fantasy comic. He could almost fly to the tops of mountains. He did everything with ease. His cinnamon skin, unoiled, shone with gold highlights, and you could see the power even in his shadow.

Nor was he slow in putting the world below his foot. In the first stage of the Paris-Nice he led across the line by three minutes after a hundred kilometre lone break – a hundred kilometres almost to the metre. Not a detail was to seem to come by chance. Fleischman was orchestrating the drama, but there was nothing in Akil of the gormlessness of Fleischman's previous champions. Akil was more than ever le patron, the imperator, the Zeus. For him no maundering, embracing, praying before the roll out. He would stand a head taller than the mean, chatting with his lieutenant the ever-present Azafrán, looking about him with slow, all-seeing eyes that wherever they settled with their purple crocus fire on other eyes gave a quick frisson of almost sexual despair – my body is dross, I am nothing – and when the bunch moved off it seemed that the peloton was more like a guard of honour than a rabble of competitors, with Akil and his chosen companions protected in the second or third rank, given plenty of air – not, you understand, out of fear for the tell-tale swerves and chutes of the imbecile. Out of respect.

But once Akil felt the strength blooming within him and he began to canter, then for all the riders the job took over, the despair melted. After all, these were still the greatest athletes in the world. Sprinters whooshed off the front like maroons, the young and bold headed off down one gutter at breakneck speed and jinked to the other, trying to throw off the chase, or break after break would go like waves of fire in battle. And Akil read the race like a timetable, seeming to know who was gone in earnest, who to make a show, who was riding with who and who impeding, where the connections would be and where the great escapes, and he covered everything as if it were a simple game.

All the way through the Paris-Nice he kept the three minutes he had gained in the first stage exactly intact. One time in the Massif Central he seemed to be caught napping. There is a feeding station, then a long section of winding up and down through woodland, then a second category climb, then a fast downhill of about ten kilometres to the finish. At the feeding

stations riders pick up musettes of their chosen fuel, honey, banana and sardine sandwiches, specially formulated fruit bars, stuff with very high calorie content to replace the energy they're losing at the rate of nearly a thousand an hour. That's one way of looking at a racing cyclist, a protein machine that converts carbohydrate into heat and energy at an exorbitant rate. Matter to movement. Sweat 'n' spirit. Shit 'n' dreams. *El Mundo.*

At a feeding station there's a bit of sorting out to be done, the bag hung over your neck to be unpacked, stuff to be arranged in pockets, sandwiches and cakes to be eaten straight away as they do not survive in pockets so well. Not to eat is to invite the fringale, when the body runs out of fuel almost as suddenly as a car does. Perhaps the rider can wobble along at a few kilometres an hour, but it's a 400 horsepower Diablo suddenly jerking along in first gear on one cylinder.

So you got to eat. But if you can judge it right a feeding station's a good place to be super organised, to miss the sandwich, keep the fruit bars for later, drop the chain a cog or two, wind the legs up to an elastic spin, almost uniform, but where you feel as the pedal goes over the top the waveform of your speed like an electric pulse; the slower pumping of your lungs, and the smooth torrent of the air.

Tiss is a tall string of piss, but deceptively strong. He looks like he's just come out of a prisoner of war camp in a central European catastrophe. His pale skin is spotty and his hair is thin. He is known as the pregnant tapeworm – he has that pot of lung below the tubular chest. Perhaps he doesn't feel pain. This day at the feeding station I am talking about, he sneaked away with a couple of team mates while the rest were distributing their comestibles. It was only ten seconds before Azafrán noticed what happened, and he shouted to the Cosimo guys to chase with him.

'Steady,' says Akil. 'It is the hour to eat and eat we shall. Then we shall ride. I have here a sandwich of cherry jam. I should hate to have to bolt it. We should treasure our digestions.' Akil bowled along, between mouthfuls talking to

Patrul and those about him of this and that and none of it to any purpose.

The peloton had entered the winding and wooded up and down bit, and you cannot talk and eat and digest and discuss the topology of three button waistcoats, as Akil wished, in this sort of terrain and maintain an adequate average speed. By the time Tiss could see the 900 metre ascent, he was four minutes up on the bunch, including Akil, on the road, and leading the whole race by seventeen seconds on aggregate.

When he had finished eating and let it settle and discussed his fill, Akil, riding alone, did with Tiss in a playful way what Baris had done with him on the Roncoli de los Machos Cabríos in the previous year. He went up the climb on the drops, as if trying out new legs for the first time in the season, as if his 100 kilometre and three minute break a couple of days before had just been a warm up exercise. Azafrán saw it on TV afterwards, and fuck knows what Fleischman had been putting into Akil but it didn't look like a drug. A drug, whatever it is, its effect is to allow the body to spend itself recklessly, sometimes fatally so. Sáenz didn't look like drugs. The camera bike was all around him as he rode. Drugged riders have that seam of despair somewhere deep inside them, as if what drives their bodies is not something that they love. Drugged riders are always looking away from something. But Akil's eyes were those of a man who forty five minutes before has been giving his professional colleagues an insight into the mysteries of topology and now out of love for his own magnificent body and glorious reputation has decided to impose his presence on a season that will define cycling genius for all time to come. The camera went in close, and there was no despair visible, only a focused intelligence and a rippling pride. Akil went past Tiss a couple of kilometres from the summit on a fifty three seventeen on an eight per cent slope and still on the drops. He went past Tiss like Tiss was just trying out the gears on his first racing bike he got for Christmas. Then a hundred metres up the road he waited for him.

Akil didn't wait for Tiss because he had blown, or because

he was wrong in the head. He waited for Tiss because he wanted to make clear just how easy is such an easy mastery.

They went over the top together and down the other side so fast that by the end of the stage Tiss held second place by almost two minutes, though the other leaders had been chasing like hell in Akil's wake. Akil gave him the stage win – not to humiliate him, but because he had tried.

Stage 17

Menaleon is not the kind of guy you necessarily want to take a piss with. You know how it is. He doesn't do anything. He doesn't suggest anything. It's just like he means, taking a piss, you're in on some secret together. He doesn't wink at you, but he might. That's how it is.

One day, it was in April during the Tour of the Basque Country and Sáenz had already added a victory in the Milan-San Remo to the Paris-Nice, Menaleon rode up beside Azafrán and said, so that others could hear, 'Your friend, tell us the secret Patrul, is there something in the Swedish spunk?'

When Akil Sáenz left QiK, Menaleon had assumed he would go with him as a super-domestique. It is true that he was no bad rider on his day, and had worked hard, if a bit unpredictably, for Akil – and he needed to move somewhere, because to stay behind and become team leader, Menaleon never had it in him. Not for the same reasons as Azafrán either. Azafrán was, by common consent, a bike rider physically in the top five. In his younger days, before Fleischman came on the scene, he was well the equal, proved to be by results which are there in the record for anyone to see, well the equal of Potocki, Sarpedón, he'd beaten Baris more than once in important races, Azafrán's great triumph in the Paris-Roubaix, the Hell of the North, being but the most outstanding. But Patrul did not by temperament or philosophy demand, desire, crave to be the greatest – couldn't give a fuck, in fact. To be honest, for Patrul Azafrán hake and garlic and a bottle of wine was more important, in the ultimate scheme of things, with perhaps Sáenz and de Zubia and a few friends who were nothing to do with cycling at all, sitting round the big table in Los Alcornoques, more important than standing on the podium with the crowds roaring and the lipstick girls kissing you because that's their job. That's great, it's happened and nobody could say it's not a great feeling, that you are the *one*, but it's not something so much, I guess, to take to bed

with you at nights if you are old or lonely, whereas the *sobremesa* at Los Alcornoques, if you snuff it and they say there is no heaven, you got to provide your own, you got five seconds, well it's not perfect, but I'd have no hesitation.

The same for Azafrán. Sometimes he'd think about the time in the crocus fields with Perlita, but it's a bit high powered for eternity. So, like they say in the comics, he wasn't hungry enough for victory. Fuck hunger, tell me this. The figurehead on a boat, what does it see? That's why Patrul preferred to be among the crew.

Menaleon, he couldn't be a team leader because he was weak and he was vain. He wanted you to admire him without giving you any reason to do so. A good team leader works for his team. He spends a lot of time thinking how to get the best for them. First in cash, which is the genuine and necessary way of showing you care. Then in conditions, accommodation, food, the right equipment, the right physical and mechanical support. And then – and it's the hardest for a team leader, who must also be an egoist, a ruthless killer every time the moment comes – the psychological support, praise, encouragement, just a friendly hand on the shoulder, only for a second perhaps, but at exactly the right time, not a second too soon nor a second too late – fierce criticism also when it's due, but again a matter of precise timing, even anger a matter of the just moment. Not one of these things did Menaleon have. He is not worth discussing further.

Fernand Escoto was the one to feel a bit sorry for. But he'd got his value out of Akil. Nobody thought the less of Fernand when Sáenz had finally decided the previous October, after much discussion, to sign up with Cosimo and Fleischman. It was widely accepted that Sáenz was selling out to the devil – tough, perhaps he had no alternative, and Escoto was the more highly thought of for being the virtuous man who would never resort to anything but good health, good training and good tactics to win. With Akil's departure, he was in an ideal position to build up a new young team for the post-Sáenz decade. Once he'd got over the first hurt of Akil's defection, he felt it was a liberation. He was a nice man, Fernand. He was

a bit like Azafrán in a way. It was the work he enjoyed, the planning, thinking, looking ahead, seeing young people come on – not the hologram of victory. And for this, he'd want a new team leader. Not Menaleon. Sadly, he said, Menaleon's contract was not to be renewed.

Akil, godfather, would have taken the shite with him to Cosimo – 'The guy's good, he's been with us a long time, you can't just leave him out in the cold to go and ride for some third-rate Belge team, Gigasrup ColostomyBag or whatever. Be reasonable, Patrul.'

But Patrul had heard Menaleon talking about Akil behind his back, from the time Potocki started to win. Patrul said that if Menaleon was signed up by Cosimo, then he Patrul would go elsewhere. He said it and he meant it. Akil shrugged and laid his hand on Patrul's shoulder for a moment and shook it gently. Menaleon had gone to a Luxembourgeoise team called Colonne Irriguée.

And now he was beside Azafrán. It was a beautiful spring day in the Cantabrian hills. Nobody was racing too hard, Akil was riding at the back of the peloton, chatting to the young guys, the unknowns, as he was more and more inclined to these days, a bit of advice, a bit of encouragement, a joke at the expense of the big guys, nothing pushy, just being there.

Without Menaleon, it would have been as perfect a work situation as you could imagine. So Patrul tried to imagine it without Menaleon. He ignored him.

'Fleischman slips it to him up the bum, I hear. You ride behind the great man you can hear the saddle squelching. What's in the juice, Patrul? You get any?'

Patrul just went on imagining. The sun had that glorious freshness of spring, when after the cold of the early races, often snow or freezing rain, icy mud, you begin to feel it work through your shoulders into the bones. Some riders don't like the heat. Patrul, like Akil, thrived on it. And this foretaste, this spring sunshine, it made all of you feel good. The bunch wasn't racing now, but you could feel the sap rising. There'd be some speed before the day was out.

'I notice you changed your position a bit. That's Fleischman's coaching is it, a touch more aerodynamic, or is it just to give your arsehole an airing, cool it down a bit?'

All nature could feel it, the eagles almost among the bright rags of cloud, the doves calling in the trees, the little birds flitting and scurrying among the bushes.

'Me, I'm not much into shit.' The guys around didn't seem to be too interested in what Menaleon was or wasn't into, because they kinda drifted back, or went up to the front to see how things were up there, leaving a bit of space. Perhaps Menaleon was too high on his own wit, the bad adrenalin that nobody else was feeling feeding itself with words. He didn't seem to notice Patrul glancing behind to see if there were any race cars or TV motorbikes about. He was lost in his own little world. 'But me, I'm thinking that up the bum is the place for shit. How about you and Akil? Share it around? Perhaps that's why that little de Zubia looks a bit sulky these days. Spunk up the bum makes you boys go so fast, perhaps the little whore doesn't get a look in.'

Patrul couldn't really make out what Menaleon was after, what he had in mind. He seemed not to be concentrating on the real world. The real world was a shallow descent through trees, among the trees were rocks the size of cars, right down to the road, you couldn't think how they got there. They looked like they had tumbled down the mountain, but there was no mountain, only gentle hills, so why so much fractured stone? A great *barco* of granite was coming up on the right hand verge at about the time Menaleon employed the word 'whore'. Patrul decided that perhaps trying to work out what Menaleon intended wasn't worth the bother. He drew in his arm to his shoulder and delivered a sharp jab to Menaleon's temple with the angle of his knuckles. Then he picked up Menaleon's wobble and with his shoulder guided him to the right. The rock did the rest. Patrul heard a crack like a branch breaking, but didn't look back.

It wasn't as bad as it sounded, concussion which left him with a splitting headache for weeks and a simple fracture of the ulna, plus the usual broken collar bone. Menaleon would

perhaps be back for the Tour, certainly for the Worlds. Minges-Cartuja put in the strongest possible protest on his rider's behalf, trying to get Azafrán banned for the rest of the season. But nobody had seen anything. It must have been that Menaleon just lost concentration and rode into a rock. A bit like Potocki, Patrul said, but without the talent. It got straight back to Menaleon. Sometimes it was worth it to add insult to injury.

Stage 18

Patrul got a message at the end of the Paris-Roubaix to meet someone in a café in Lens the next day. From the phoney address, El Desfiladero de Despeñaperros, he guessed it came from Andujar.

The café was one of those slow surprises in dull towns where the coffee is so smooth and oily you want to squash the scent out of each sip with your tongue, and the cakes are shocking as the silk under a nun's habit. Patrul got espresso and a thing with black chocolate and spurts of moist ginger.

A couple of minutes and there came in a punk chica with short black hair and sour boots, smoking a roll up. She bought a corto and came to his table, she sat down without any formal request and at a point when any man might have raised his eyebrows in civil enquiry she said, 'What are you looking at, fuckface?' The voice was throaty like wild honey and the aura was cigarettes and Viburno 'bitchi', so he breathed in Gabriela Gomelez before he caught the half second pleased to see him smile just round the eyes which she immediately turned off for professional reasons before it drew attention.

'Look,' she said, very quiet and intense, 'I want to stay here five minutes only, if that. I may at the end of all this be able to save your ass, not that it's a priority.'

'From who, from what? I'm not scared.'

'Well, be scared.' She sounded almost as if she cared about his fate. 'Listen, in Andujar you were right. First the case was sent upstairs "for my protection as a woman". Then I got the anonymous warning.'

'Yes?'

For the first time she looked right into his eyes.

'Then you are a woman of courage.'

'Fuck courage. I've just got nowhere to go.'

'Drop it,' said Azafrán. He too was in danger maybe, he saw it, but this woman, what could she do, and why should the

powerless suffer? 'Walk away. You have your career. The criminal justice system is not to be sniffed at.'

'And?'

Patrul was silent. Women too have their honour.

'There is always a way in,' she went on, 'a way under the skin. That's why it is you I need to talk to. To ask you the way in.'

Patrul shrugged. 'The dead guys, they seemed like they were doping, it is true. But they were not. The tests these days, your brand of hair gel they can tell from a drop of your piss. Blood tests, they can tell where you live to the nearest kilometre by the pollution fractions. Some, in the wind shadow when a factory process releases atmospheric toxins according to a known schedule, they can tell what day the blood was taken to the nearest hour.' Gabriela began to look a little impatient at the generality of this introduction. 'So,' Patrul summarised, 'no chemical. Something – hypnotism? No. You know the body of a cyclist, on the top, he is a very complex psychosomatic entity, endorphins, enkepahlins, paranoia, money. Hypnotism? Diet? Magic food – I think about that, but it's comic book stuff. So . . .' He shrugged. What could he do? At no point, beginning, middle, end, do you determine another's destiny. Shit, your own, even that, it's like steering a bus through an unknown city in a dream when some joker has put the steering wheel up on the roof and halfway back so you got to half guess and half remember what's under the wheels.

'Look Señora Gomelez. Doping, I don't do it myself. I don't do it because I am lucky. I have ability and I don't have to prostitute myself. Prostitute. I use that term with respect, Señora. I don't mean the kind of whore who does it because she got her flesh as a certain business and she's very good at that business, like her body is a hotel, this way in, that way out, these are the rules, the tariff hangs in the lobby, she treats you like you're ordering an expensive meal but she's only the waiter, she's not the cook – see what I mean?'

'Patrul, I think you overestimate my . . . I have never . . .'

'Me neither. No, when I say respect I mean the kind of girl

126

who has to, she got responsibilities, a kid, a sick mama, a dying granddad, she got to go out and sell her cunt, but she isn't no hotel, she feels it and she feels it hard, she is suffering in this world, and that's because she isn't one of the lucky ones. The guys who do doping, Gabriela, they are whores like that. Don't sneer at them.'

'So Akil is a whore like that?'

'You already give the answer. He's not doping. Therefore he is no whore. See, I think about this a bit. To me cycling is a way of life, it gives me money, it gives me friends, something that makes me get up in the morning, something to talk about, a bit of fame perhaps but that's not what's so important. It's a job, that's what's important. But there's another thing, one you can't make a lot of sense of, what it's also about. This human body, does it have limits? Who wants to know? It's stupid. Fuck, what difference does it make if a man on a bicycle can go fifty kilometres in an hour, or one hundred fifty? You know what Francesco Moser did when he beat the hour record? He trained at altitude so he got plenty more red blood cells, and every day he got some taken out and they'd centrifuge it and freeze the RBCs in glycerol, then before he went for the hour record he had all that rich red blood pumped back in again. Now what you got there, Gabriela? You got a tube and a cylinder and a piston and you put the tube through the skin and work the piston in and out and so on. OK, it's over a bit of time, and the piston doesn't power the body like in a car, but I see Moser, a fine man and a fine cyclist, riding round in my head and I see that glass and steel pumping the blood out and pumping it back in again, and I think so what's the difference.

'You seen the film Robocop, Gabriela ? That's an interesting movie. Ever watch American football? I think one day it would be interesting to have the Dallas Cowboys play against robots. The robots would be good – then they would get better. Soon humans are out of it altogether. An American football game between two teams of robots, now that would be an interesting contest.

'We're not talking whores here, are we Gabriela, we're talking cybernetics.'

It would be wrong to leave out that she looked impressed by this analysis. Up to that point she might have thought Patrul Azafrán was just a dumb fuck bike rider. Even so, she wasn't convinced by the argument. 'So you're saying you're happy to see your friend turned into a machine. If that's going to make for more interesting cycle sport.'

'Life's a machine, Gabriela. A wet machine.' He tried laying his half closed hand very gently on her arm, edge down. She didn't jump. 'Maybe it *is* like the whores. Respect. I don't know why a guy needs to do things with his own body. That's not my decision.'

She looked down at the hand on her arm and she kept her eyes there like she was reading it. 'Look, Patrul Azafrán . . .' She didn't raise her voice, but you could feel the pressure going up. 'I need to know. I need to know everything there is to know. Why? I don't know that till I know it. That's the thing about finding things out, isn't it Patrul? Only the ignorant don't know how ignorant they are.'

'Señora. You say I am ignorant?'

'Oh no, Patrul, you're not ignorant. You're like me. What we got, we got in here. Some of it's common knowledge, some of it's common sense, and some of it's not very common at all. Keep in touch.' On the table she left a small package which Patrul immediately slipped into a pocket. Then he became paranoid, thinking a set up, so perfect to link the noble Azafrán with the emblematic white powder. Later, as he walked to the station unchallenged, he felt good that it was possible to be paid a man's compliment by a woman.

<center>*</center>

Since they had moved to Cosimo, Patrul and Akil no longer shared rooms during races. Patrul's room-mate was now Jacobi, the first year professional who had moved with them from QiK. Patrul liked him. He was one of these new style of very slow young men. His eyes moved slowly to you when you spoke, lingering on a few little things on the way, his

smile moved very slowly over his face, and you often had to wait around like it seemed several minutes before you knew whether he had anything to say in reply to you, or whether your conversation had just drifted slowly away on the breeze before Jacobi had got around to getting his attention to it.

They called him Torbellino. The Whirlwind.

On a bike he had a sudden thing he did like the Diablo winding up to deafening revs until you think it's going to bore up into the sky and disappear. He was only twenty three, and already he was a top sprinter. It's a dangerous game, sprinting. At the end of long flat stages when there hasn't been a breakaway, all the sprinters are jostling and twitching, looking for their team mates' wheels to lead them out till they can thrash into the last hundred metres on their own. Their nerves are running on ninety seven per cent adrenalin, their fuses so short that if they were off their bikes and a leaf fell on their head they'd beat it to pulp; and then somewhere inside someone's head the little glass capsule shatters, the acid snaps the spring, muscles convulse, tyres lash tarmac and they're on their own, elbows overlapping, bikes barrelling through forty five degrees beneath them as they screw them left and right, arms heaving, feet whipping, riding inside the arc of each other's elbows, trying to get down the inside, through the gap that opens and closes three times a second, round the outside of a guy who's going nearly as much across the road as along it because he's got his head down between his knees because that way he can concentrate exclusively on pulling the bars off his machine without distraction. It's a surprise any of them get home without an ambulance. But somehow they do, most times.

Your usual run of sprinters, Patrul thought it didn't matter that there wasn't a lot of brain there, less to get pulped when they charge into the barriers. But Jacobi wasn't nearly as dumb as he seemed. Not nearly. And he could do more than sprint. Patrul thought that one day he might be a rider of significance. Another Jalabert perhaps. And then he wondered what Akil was leaving to be significant about.

Stage 19

Perlita de Zubia went into labour three weeks late and late in the afternoon of Tuesday 13 April, eve of the Flèche Wallonne. Patrul thought she looked like the Queen of Sheba but she, with the complex curve she lugged in front of her like half the world in sinusoidal projection, her patience had come to its end. She had tried practically every trick her grannies, on the end of distant phones in mountain villages, could invent as ancient lore, and was beginning to not just eye the Diablo, but go and stroke it as well, in a way that made Akil bite his fingernails and look around for distractions.

On that April evening he had taken her up into the hills. They had walked along a rough track among chestnuts and then higher into the herbs and scrub. Out of nowhere, in the middle of the path, two snakes had reared up and hissed at them, swayed, turned, gliding off into a black hole between boulders. She had leant against Akil and held him. She was breathing quickly, with excitement, no hint of fear. They did not cross the place where the snakes had been, but turned back to the car. As soon as they were home and she sat down she realised the contractions had started. She insisted that they call Patrul, who was up in Belgium to ride the classic and, many said, likely to win in Akil's absence.

At Perlita's insistence on Patrul's presence a huge soft sadness came over Akil, as if he might melt, beginning at the hands, but when she saw it she said, 'Have no fear of anything my love – it's you I'm thinking of. At times like this you're just a big kid and you need another big kid to look after you while I get on with things.'

Patrul's only regret when he got the phone call was that he couldn't ask Tiss and Carabuchi to return the dough he'd given them – not *buying* the race, you understand, just an agreement that, at his age, he shouldn't have to bust a gut for victory – but his sense of honour was absolute and anyway

such requests led to messy arguments. Much better to pay up and preserve a spotless reputation.

He was sure he would arrive long after the birth, but when he got to the hospital on the morning of 14 April de Zubia was still in labour, very tired, but smiling to see him. Akil had been with her all the time, doing whatever it is they do, and everything was OK, they said, mother and baby very well, it's just that the cervix was being very slow to dilate, then they could get going. Perlita said that Patrul should take Akil for something to eat in the canteen.

They loaded a plateful of stuff each, but Akil only took a couple of mouthfuls and then pushed his away. Patrul went on eating. 'It'll be fine,' he said. 'I know.'

'Fine fine fine, everybody says fine. What the fuck do you know about fine? How many kids have you had?'

That's OK, fathers in childbirth they say all sorts of things they don't even remember later. It's the hormones.

When Patrul is finished they go walking across the hospital grounds for five minutes and down through the ramparts of the old city and stand in the lists, looking to the east over the spring orchards, the market gardens and fields of green wheat. Birds are singing, and it is difficult not to be happy, except that when someone is in childbirth there is a fear underneath that is equal to the joy. Partly it is death, and partly, if not death, then all birth brings to the unborn – 'what are men, doomed to death, dwelling upon earth, troubled by ills without number, eating barley from the fields they work, dwelling with female spouses.' Patrul read that somewhere, Greek. There were tears rolling down Akil's cheeks. Patrul clapped a hand to the shoulder. 'You cry!' he said. '*She* has something to cry about. How would you feel with a pumpkin coming out of your arsehole?' That made him turn away in anger and walk off.

OK, it's not a pretty comparison, but better to have him angry than sobbing.

'You can just laugh at anything,' he shouted over his shoulder.

But Patrul was not laughing.

'Sure you're right,' Akil went on, walking back fast towards the maternity wing. 'Never to give yourself to anything, that is the best. Bike racing, love, trust, you set yourself up so that people can diminish you. Best to be the bee, buzzing from flower to flower, eh. Then you can never lose. Why not? Because when losing time comes around, you're gone, you're not there any more. You're just not there any more.' When he said it the last time he stopped and turned and looked at Patrul. Then he ran across the grass and into the labour unit.

That, to the friend who has stuck by him all those years, that hurt – but, as was said, it is the hormones. That's one thing you could say for Patrul Azafrán, he was always there – otherwise how come he wasn't in Belgium at this moment, most probably winning the Flèche Wallonne.

Patrul went slowly up to the maternity wing, thinking how could it be his fault if de Zubia insisted on doing certain things, and how things would turn out if the baby was a grinning dwarf. Patrul himself did not object to being not so tall, and he smiled a lot because he liked people and they liked him, apart from ratshit like Menaleon – but it's not the kind of thing you would wish on a child.

He went and cornered a nurse to ask her to find out how things were going. He tried not to grin at her. He tried to be grave. 'Cheer up, kid,' she said, and took his chin between finger and thumb and pulled his jaw down and made a sad dopey face herself, 'everything's fine. It'll probably be another hour or so. Go and get yourself a cup of coffee.' She brushed her front lightly against his side as she went off, as if there wasn't quite room to get past him, though there was a good three metres clear. Patrul sighed and smiled. There is no point to try and change the kind of prick you are.

It was three hours he sat in the lobby while other anxious people came and went. 'It's fine,' the nurses kept saying, 'it's her first, these things cannot be hurried. Go away and leave us a number, we'll phone you. You're not doing anyone any good here. And don't gnaw the magazines, please, others may want to read them.' But Patrul knew deep in his heart it was

not fine, that it could not be fine, that the delay meant things were going wrong, one after the other, and in hospital they never liked to admit that there were situations over which they had no control, that most things that went on in hospital weren't fine at all, at best they were the best of a bad job. So when the nurse who had pulled his chin came, looking tired now, and with a grave face said they, his friends, would like to see him, he gabbled, what was it, was it all right, and she said they would prefer to tell you themselves, and he went rushing in, the blood had drained from his face and he was sweating, and there was Akil standing by the bed in just a tee shirt and jeans, his normally dark cheeks the colour of parchment, holding de Zubia by the hand. Her face was a bit soft and drugged and swimmy, and on her breast wrapped in a cloth or something was this bundle. She gestured him over and gave it to show him. A face only slightly crumpled, a load of dark hair. 'Is it . . . is it . . .'

'A girl,' said Perlita. Patrul never knew afterwards whether she knew what he was asking. At that moment it opened its eyes in a bottomless crocus squint, took Patrul in, and closed them again.

'She's called Iridacea,' said Akil.

Patrul gave the baby back to Perlita, kissed her on the cheek, and embraced Akil. 'Iridacea. Is that any name for a frog?' he said through the tears.

He went to get the bottle of champagne he had bought on the plane from Belgium out of the nurse's fridge. His friend was there. He tried to embrace her with the happiness he felt, but she put a firm finger in the middle of his chest. 'When it's me you want, Señor Azafrán, come back for me. I shall be waiting.'

Patrul looked at her then. She was nothing special, just a nurse, medium height, brown hair, brown eyes, nice shape – but at that moment he knew he could settle down and live with her and she would be the perfect wife for him and mother of his seven children. 'It is an agreement,' he said. He meant it. She smiled, shrugged and turned away. She liked this famous bike rider. She could see he was the kind of guy who

always meant things. She was tired, and there was another two hours of her shift to run.

While Patrul and Akil drank the champagne a midwife introduced Perlita to the techniques of breast feeding – 'Don't worry,' Perlita said, 'I'll just stick it in and she'll suck, we're that kind of family,' but the nurse said it was the procedure and it wasn't always quite as easy as it looked. Then they said she could have a bath and something to eat, and the men could come back in the morning.

Patrul drove Akil home in Akil's car, and went in for a bite to eat and another bottle of champagne. Over the rice and sardines Akil began to talk. He hadn't slept properly for thirty six hours, and the champagne made him woozy.

'Anything disappoint you?' he asked.

They were old friends. It would have been disrespectful for Patrul to pretend that he didn't know what was meant, so he just looked at Sáenz across the low table and when their eyes were fixed he smiled very gently and shook his head very gently. 'And you?'

Akil sunk his face into one hand. 'I'm sorry what I said down in the lists. I am so − so tragic with myself. Today I would be a person who works in the bank, or in the factory. Just an ordinary little house, money short, presents for the kids, a new car once in a while, holiday to the mountains, me and Perlita. But I have it in my blood now . . .'

'What's that, Akil?'

They talked for an hour or so, but Patrul learnt little that he did not know before, certainly not what Akil thought he had in his blood. Then the eyelids of potentially the greatest cyclist known to history began to be closed more than they were open.

'Be happy,' said Patrul as they embraced once more. 'You have chosen, so don't look the way you didn't go. I'll bring your car back in the morning, if that's OK.'

'Six,' said Akil Sáenz. 'We'll just get in 120 kilometres before it's time to go to the hospital.'

Stage 20

Whether you want to know something or not it often happens that nobody's interested at all in your requirements and you just find it out, you are looking at it and you don't know what it is and something way inside you says Uh-uh! Look away, little fella, look away, but your reactions are untrained and instead of looking away you poke your snout in even closer and by the time you have told yourself no no, I do not want to see this, you have discovered in some detail just what it is you did not want to see, and it is with you for the rest of your life.

This is not a part we're going to linger on. Forensic. The bits of a cyclist that get all the public attention, the legs and heart and lungs, they are as much use as a dildo to a blind donkey without the pivotal skin tissue, the place of darkness, the crotch. Think about balancing your body weight on a big scarlet and yellow abscess on the ischia, then pedalling two hundred kilometres. Then when the boil is well and truly mashed up, getting on the bike the next day and doing it again. That's why good shorts are so important.

Bike riders' shorts these days are very good. That was not always so. This is what they used to be like. Black wool. Wool when it's damp however fine it is it's scratchy. Imagine rubbing the end of your dick or equivalent gently on a bit of damp wool for seven hours without a break. So there's an insert for the crotch, chamois, the fine skin of a kid's or a calf's belly, and you rubbed it with something like lanolin to make it soft, and the sweat made it supple, and it treated your underparts real good for a bit. But this soft and suppleness was, you can imagine, also a rich bacterial slurry. After each day's racing you had to wash your shorts very carefully, and when you'd washed it the chamois was slimy like the skin of a long drowned thing. The skin of a long drowned thing would feel kind of loathsome next to the knackers, so you had to dry it, and that made it like parchment. So you softened it with

lanolin and sweat, and the cycle went round and round, like they do.

Old-fashioned shorts, scratch and slime.

But the new bib shorts are a work of art, lycra sewn in six or eight panels with straps over the shoulders, and this synthetic chamois that never goes slimy fronted by an arc of poly-propylene knit and a film of foam that wicks up the sweat as fast as you can pump it out. So you still need to wash them, but they're soft and dry within the hour.

The moment was so quiet, so domestic.

There's nothing wrong with suppositories. There's more than one way into the body. In the healthy human the nose is the most used, followed by the mouth. Poison has been dropped in ears. There's the puncture in the skin. Stuff doesn't go in so easy that way, it needs the piston to push it through. But there's diffusion through the dermis, with nicotine patches and stuff. There's smoking, tobacco and opium and crack cocaine. Alcohol will drift into the blood through the membranes of the tongue before it gets to the stomach. Then there's up the arse.

Every way in is also a way out. Ears erupt slow motion wax. There's snot and piss and breath, there's vomit and jism, kisses swap spit, cunts ooze juice. We make judgements. Shit comes low in them. But nothing has no possibility of pleasure. The airy orgasm of the sneeze. Even as you puke there's a percentage of joy in the matter, the force of the expulsion.

What Patrul understood so far: something from America, a process perhaps involving human cells, or proteins or some mystery stuff not yet described in the literature, was maybe being imported to a lab Fleischman had in Siena. This was what had given Potocki, Sarpedón, Baris their tremendous power. This is what he was putting into Akil.

The stomach is a hostile environment to most living things. It's even a hostile environment to itself. It needs a lining of thick mucus to stop its own acids digesting it. The delicate and migratory seedings that Fleischman wanted in Akil's body wouldn't have survived his stomach for a second.

The rectum is a gentle environment, moist and warm. It lets

things be in there. Why did Patrul push Menaleon into a rock and not care whether he broke his neck just because Menaleon made certain accusations? Would it have mattered if the accusations were true? They were only dirty because of the mind they came out of. Some minds are worse than any arsehole.

That's about it. That's all there is to say on that subject.

Early in the morning the day after Perlita gave birth to Iridacea, Patrul drove round to Akil's place. It was the middle day of April and the birds were singing hysterically from the orchard beyond the house and all the trees of the hillsides. Fleischman's Barus Merc was just pulling out of the gate as he arrived. They chose not see each other. Patrul got his bike off the rack on Akil's car before he went in. He adjusted the brakes a fraction, took an eighth turn on a couple of spokes. He knew that Akil needed a bit of time to compose himself after Fleischman's attentions.

Fleischman was a great sports doctor. Leaving aside whatever else he was doing he could help a rider to understand his own body, be comfortable with it and look after it like no other doctor Patrul ever knew. He would discuss things for as long as you like, from ingrowing toenails to IGF-1. Nothing too small, nothing too big. And it seemed when he was discussing things with a rider, calculation didn't come into it. He told you everything you could understand, how it works, whether it works, how it damages you, what age the damage is likely to show, whether you are likely to breathe slower and slower until you aren't breathing at all at three o'clock in the morning like happened to too many Dutch guys, why Anquetil died of stomach cancer, why Billy Bouvines believes in exorcism. And he told you the good things, how to eat and sleep and rest, when to give yourself pain and when to go out and enjoy yourself. He gave a lot of time to each rider, so there was nothing unusual about the times he spent with Sáenz, in the team hotel or at his home or wherever.

Just sometimes things didn't seem to go quite right. After the Paris Roubaix you could understand it. Perlita's delivery was overdue and immediately after the prize-giving Akil said

he was leaving. Before that we thought he was going early the next morning. Fleischman says OK but you have to have a quick check on the team bus. Akil says he has a plane to catch. Fleischman takes him aside and there's a bit of arm waving. Akil, in shirt and jeans and with his overnight bag, slouches into the bus. Patrul sees he is angry. More than angry, Akil has that face going when he talks about 'the plan', where the rage is half drowned in despair.

Fleischman goes to the boot of his car. Patrul cannot see in, but a wisp of steam or dry ice is swirled into nothingness as he slams the boot. He comes back with a smart black briefcase. They go into the medical cubicle together.

Now these team buses are big affairs, with kitchen, shower, changing rooms, lounging area, TV and hi-fi, but they are not designed for confidentiality, and the medical cubicle is only a big cupboard with an examination slab and some basic potions and lotions and gear. The guys are drifting in and out to catch their interviews on TV, a cup of coffee. There is angry speech through the partition. The two inside are holding the anger in and you can't make out the words but Patrul turns up the TV loud anyway. Then Akil comes barging out, doing up the belt on his jeans. Nothing wrong with that. Fleischman comes after him. No more he's like the father, the hyper-intelligent guiding spirit much older than his years. He is like a woman and he's plucking at the sleeve of the brute who is going to smash the skull of his child against the wall. He tries to hold the sleeve of Akil's shirt, and Akil raises a hand to strike him.

And now Patrul is on his feet, he is the father now. With the authority of a first among equals he signals the guys with a gentle frown to get out then, not knowing what the fuck's going on himself, he lays a hand for a second, just the right second, on Akil's shoulder, makes him turn to face the almost weeping Fleischman, and then he goes out too and shuts the door.

Five minutes later out comes Akil, to the sparkle of a hundred flashguns, that's to be expected, that's just background noise, but he's not looking like the winner of the Hell of the

North, he's not looking like a man who will soon set eyes upon his firstborn, he is looking like the victim of a psychic assault, the bruised eyes, the careful walk.

When Fleischman comes out a couple of minutes later he's back in command again, the black briefcase swinging, glasses glinting, the thin cynically warm lips smiling here, there, giving the guys to know that it's all alright, Daddy's home. He comes over to Patrul. 'I just gave him something to wind him down a bit. No wonder. Your first child, perhaps something we will never know, eh, my uncle Azafrán, but something nonetheless.' Patrul looks at him, not smiling, not frowning, just tapping a finger across the knuckles of the other hand, as if checking off units of time of which there may be many before this thing is decided. Eyes meet quiet for a second, then Fleischman goes to his car and, not returning the briefcase to the boot but throwing it on the seat beside him, drives off.

That's why, now, Patrul gave Akil a moment or two. Then he went in and Akil was putting the fruit and muesli on the table, and when they were ready they rode the 120 kilometres before it was time to go and see mother and child in the hospital.

It was then. It was just a thing you do when you are very familiar with someone, when you have been like a brother. While Akil was in the shower he walked through from the spare room which he always used, to the bedroom of Akil and de Zubia to pick up Akil's fallen kit and put it with his own in the washing machine. It was an automatic thing to do. He did not know why he looked in Akil's bib shorts. That was not automatic at all. There was a stain on the artificial chamois. Not shit. Like coral. It was such a small thing. The moment was so quiet, so domestic.

Very carefully Patrul arranged everything back as he had found it, and went out and waited for Akil to come out of the shower.

<div align="center">★</div>

At the end of that week Akil Sáenz won the Liège-Bastogne-Liège. It is by common consent the most challenging and the

best classic with its taxing Ardennes climbs, as well as one of the oldest. Akil the new father was fêted before the start, and he won gracefully, that is to say by working with every break as if he were just one of his team, taking his turn at the front but no more and at the end, though he is no sprinter, waiting for the sprint and contesting that. Jacobi the Whirlwind led him out just a few metres earlier than was ideal for the other true sprinters in the lead group and Akil mixed it with them elbow for elbow and lunge for lunge and went over the line a rim's width in the lead. The crowds were ecstatic when the photo finish was announced. To win by kilometres was impressive but it was sombre. To conquer by a finger's breadth was like we mortals do it. They were able to love him.

Two days later Akil said he had to go again to Siena for some tests. Patrul tried to get him to talk about it. 'Mikkel,' he said, 'he's a damn fine sports doctor, but if it's not bust, don't fix it. You just won Liège. You're training well. What's the point of the extra travelling?'

Akil dropped a cog and racked up the watts to make Patrul breathe harder and discourage conversation.

'I didn't win by so much,' he said.

'Come on, that was playing. You know that was playing. That was the most split second timing I've ever seen.' Patrul, who had worked tirelessly for his leader, did not finish in the winning group but he'd watched the finish on video at least ten times and been astounded by Akil's dramatic flair and the risk he took – not just of injury, but a puff of wind in the wrong place and a win by twenty millimetres can become an unlucky second place, same time.

Akil put on a bit more power. This was ten minute interval stuff. While they ticked by he strung Patrul along so that he could only just keep contact, and it hurt. Patrul knew that if he lost the back wheel then Akil would drop the pace, but the man had pride. He kept up the high racing speed for the demanded interval, his big jaw dropped, his lungs pumping on the edge of arrhythmia. Akil did not even open his mouth. That was a measure of the man's ability at that time. He could

tow someone of the ability of Patrul Azafrán along like a gasping fish, and breathe through his nose.

'Bastard,' said Patrul when they were riding side by side again. Akil turned and smiled at him. It was the smile of a friend and also of a generalissimo unchallenged in his greatness. Then he turned his eyes back to the road. He was such a rider. He was dawdling now in the high sun in a middle gear, the liquid crystal scanning an unbroken 40 kph, his hands draped elegantly on the hoods, his arms, not locked lumpy like some, suspended in a relaxed curve like a resting dancer's, his legs moving so fast but so easy and graceful it seemed as if the power came from elsewhere. 'Bastard,' said Patrul again, and again Akil turned and smiled at him, but this time he shrugged slightly as well. Patrul could have finished it all with a smile in return but he didn't. 'What does that mean?' he asked.

Akil kept his eyes on the road ahead. 'Too late for questions,' he muttered at the end of five minutes, and upped the watts to a level where Patrul could ask no more.

So he went off to Fleischman for a check-up, and Patrul stayed at home.

<p style="text-align:center">*</p>

Perlita sat with the early morning sun through the glass roof dancing with leaf shadows across her and her left nipple half way down Iridacea's throat. They looked so good. The light was straw gold, and de Zubia sprawled in a faded blood red leather chair in an old cream silk dress with moss green flowers curling round its folds. It was already warm. The dress was down to her waist. The tit that was not in Iridacea's little gob stuck out like a rugby ball, ribbed with blue to the startling earth brown of the nipple. Some old Cumbia bounced quietly on the hi-fi. Her head rested back in the black curls, and she watched Patrul unblinking as he watched the little cheeks move in and out. The soft git, thought Perlita, noting the gleam of surface tension across the eyeballs. Then he turned away and went to the window. He looked absurd in his cycling gear. They always do, chicken legs and knees overhung

with muscle and bums like breeze blocks. And if they have their shoes on they have their legs braced back as if they're sticking their tackle out for a mug shot. 'I was just passing,' he said, 'and I thought I'd see if there was a cup of coffee about.'

'No,' said Perlita, 'we drink milk, water, fruit juice, Iridacea and I.'

'Can I make myself a pot.'

'No. I do not want to smell it. Do you know, a baby is more likely to be ill if the father smokes, even if he never smokes in her presence.'

'You're crazy,' said Patrul. 'I never smoked in my life.'

'But think of the smell of coffee.'

'I am.' He breathed, longing for it.

'There's a jug of pomegranate juice in the fridge. Bring me some too.' When he had, she went on. 'Substances, you know, they don't only go into the body through the stomach. Look at her skin. It's like gossamer. The smell of coffee could go through it into her blood. I'm not having that.'

'There's such a thing as being too careful.'

'Oh yes,' she said, 'I know. But we women don't have to jack into every kick the boys put about. Drink your fruit juice.'

Patrul sipped it. He didn't like pomegranate juice. Coffee, that's what he needed in the morning on a training ride. 'You seem to have something in mind,' he said.

'Is that so unusual? I do *have* a mind. I'm not just a milk machine.' Deftly with two fingers, as if she had been doing it for months, she withdrew her nipple from the baby's mouth, a slick brown teat so extended it looked, he was shocked, invasively sexual, and transferred Iridacea to the other side, where she slept for the moment, a little globe of thick milk suspended above her from the other helmet of swollen flesh.

'You must be worried.'

'Patrul, is this the time?'

'Between now and the Worlds in October is practically solid racing. Fleischman has a programme for Akil that seems impossible. But Fleischman is not known for rash judgements. He means Akil to take the lot.'

She repeated it, not exactly imploring, but giving a lot of weight to each word. 'Is this the time?'

Patrul knew that they were both thinking the same thing. But who knew? It seemed quite possible that the priest had been mad, that Ettore Baris was genetically given to religious mania – it turned out he had a sister who was a nun – that he really could have retired at the end of the previous season and led a quiet, fulfilling life of his own choosing. But if that wasn't the case then what were the prospects for Akil when he had finished his programme, when for merely human bike racing he had enacted the end of history.

'No,' he said, 'this is not the time. But we need to keep our eyes open. We gotta be ready. Soon I have to tell you.' He put down the barely touched fruit juice and went and kissed her on the forehead, but she slid the kiss over her nose and down to her mouth, and Patrul was astonished by it and went limping out like the funny man in a movie, and got hurriedly and uncomfortably onto his bike.

That evening about seven he got a phone call from her. 'OK,' she said. 'I'm ready. You'd better come over.'

Stage 21

To catalogue Sáenz's every victory, it suddenly becomes oppressive. They can be found, accounts tainted with wonder and irritation, in all the comics of the time, and several serious books as well. But they are the catalogue of the outside of a bike rider only. They are hollow.

Akil won that year the three major tours, the Giro, the Tour de France and the Vuelta. The greatest of these, the Tour de France, he won for the sixth time. The other stage race victories were Paris-Nice, Tour of the Basque Country, Tour of the Mining Valleys, and the Dauphiné Libéré. He won the following classics: Milan-San Remo, Paris-Roubaix, Liège-Bastogne-Liège and the San Sebastian Classic. This last was in the second week of August, and it was all he did in that month apart from, on 18 August, he broke the World Hour record in Manchester by covering a distance of 59.753 kilometres. We say the end of history. Who knows what evolution may bring.

The shadow hardly fell across the first half of the season, or only like a thin veil that softens the highlights, the necessity for Mikkel Fleischman to be physically with Akil it seemed like every other day. Guys made jokes. Not vicious like Menaleon. Perhaps they were even kindly, because they pointed away from the true thing; that, to put even the best face on it, Akil's succession of unparalleled triumphs depended at least in part – and a man must also have legs and heart and lungs and the deep focus of the will – on sports medicine of a very high quality indeed, and sports medicine, whatever procedures might be included by the term, that nobody else was getting.

How much had Akil probed in those private times with his physician? Those procedures – after all, Patrul knew enough about them and it wasn't his body. Gabriela, if she really believed what she said, had a handle on the whole system. Maybe others too. Hatreds, jealousies, mere cold disapproval, these things snag and ravel the most carefully placed shroud.

What happened in the Tour de France on the col north of Pamplona, that was perhaps the time when you realise that any hypothesis about a crime is just a diagram of a landscape. It was only a little climb, Lizarietta, on the very west end of the Pyrenees, Patrul would never have even known the name of it if it wasn't a home place for him, going up from the main Pamplona-Irún road quite close to Ventas de Yanci where is found los Alcornoques.

The first week had been something like a holiday for Cosimo, Sáenz's new team. Nobody had any responsibilities but to protect Akil. And the guy didn't need protection. He was so full of life it seemed to be bubbling out of him. He chivvied and chased, shouting and laughing like the joker of the peloton – not mad, not daft, you understand – like somebody who has recently been given a baby daughter whose eyes are turning from the deeps of birth to mauve, like somebody with so much strength in his legs he doesn't know what to do with it, so instead of riding fiercely at the front with a badger scowl like Hinault, or tucked safely back in the neck of the bunch like Indurain, ready to unleash the huge strength only when necessary, he was playing the shepherd's dog, up and down the road, seeing to it that his team-mates made good. He had instructed Jacobi to win the green points jersey, and at the hot spot sprints there was Akil, crocus eyes glowing like torches, bronze hair vibrating in the wind, leading out the youngster and practically sling-shotting him across the line by will power alone.

The commentators could make nothing of that first week because it wasn't tactics, it wasn't the serious work of men. It was too like play. In fact it was pretty fuck close like satire. Here he would send his own Cosimo team, led by Patrul Azafrán, on a spirited breakaway while he buried himself at the back of the bunch. Then, when they were a minute clear he'd charge up the gutter, waving both arms and shouting instructions, and lead his old team, QiK, across the gap, telling them that Patrul was the danger man, that unless they helped Akil to hunt him down, the great Azafrán might at this very moment be tipping the balance of the Tour and thus of

history, such were his reserves of talent, strength and stamina – an exaggeration, perhaps, though not quite the big joke some tried to make it. Then, when Qik and Cosimo had this in-depth break, but no idea what they were meant to do with it, he would drop back to the bunch and once more bring up a gaggle of middle talent riders who had not yet got across on their own. Then, the crazy job complete, he would harangue them all, this leading group that he had made – had they no hearts, no feelings. Did they not care about the water carriers, the grand old men of thirty five and the infants of twenty two who struggled along back down the road behind them, their hearts heavy and their legs sore. Slow down, with me, slow down with me, he cried, and give the poor fuckers a chance.

This was tactics and strategy turned on its head, it was carnival and misrule. But he was not mad. Patrul ate with him every night, and he showed no sign of derangement at all. Nor was there any malice in what he was doing, it was not cat and mouse, it was mere exuberance. What is more it had a useful effect. So confused were even the *directeurs sportives*, let alone the riders, that nobody knew how to read the race. And in amongst the play he would let nobody really escape. If any-body jumped off the front without his say-so and began to build up a lead, Akil would pull a group across to them with enough of his own men to slow it down, and then drop back for more amusement. Now it is one thing to go for the lone break and perhaps be caught by the charging peloton a few metres before the line. But to be methodically brought back to the flock like a wayward sheep, that is demoralising and not worth exposing yourself to. In the end even the young Turks watched Sáenz and played his game, waiting for the inevitable weakness that every human being must show.

So there they were, on Lizarietta, this little Eden of a climb, barely 500 metres, through chestnut and oak, with a bright stream now this side and now that, the sun clearing the last cool touch of mist, nobody in a huge hurry. Nearly at the top where it briefly steepens were five or six Qik and Cosimo guys, climbing together for company and to show the spon-sors' jerseys to the TV cameras rather than for any strong

racing reason, and a hundred metres down the road Sáenz, with Azafrán riding one side of him and Jacobi the other, chatting about the harvest of the little migrating birds for which towers are built in those hills, and whether it was sport or slaughter.

Patrul saw them even as he was rounding the hairpin below and felt the need to say something, to be between Akil and the crouched figures. 'Jokers. Be vigilant,' he told his companions by way of psychic warning, because obviously Akil and Jacobi too had noticed the three, no other spectators in sight, crouched with their backs towards the riders, filthy ochre cloaks pulled around and down like the carapaces of beetles, straw hats on their heads.

The eruption of fiesta. What merriment! When the cyclists were but ten metres off, the three sprung from the crouch and span, their capes wide like wings across the road. From their gourd rattles snickered a chitinous off-beat shuffle and they began to sing raucously to the tune of 'The Cockroach'. 'Cucharadita, cucharadita . . .' they screeched, getting between Akil and his outriders, 'the little teaspoon, but where's the cup, what's it up to in there?' They were dressed in cheap parody of bandits, bodies flapping with bandoleers, knives, pistols, bullets, leather, all badly cut out of cardboard and painted with brown and grey and ochre poster paint. They stank of rotten meat. One had a child's red and green plastic guitar, and strummed cretinously. 'Las salchichas, las salchichas . . .' 'What does the butcher do with his sausages when he has made them big and fat?' One was broad and sang in a ho-ho bass, the second a thin baritone squeezed down the nose, the third a high falsetto, a woman trying to sound like a man trying to sound like a woman. 'El rey Chorizo, el rey Chorizo', 'The King, huh, the bum of the pack without his slippery envelopes stuffed with borrowed meat.' They had on Zapata moustaches and short ragged beards, and as they squawked and ranted they rolled their eyes and bared their teeth. 'La carne muerta, la carne . . .' 'The legs of dead men, can you turn that heavy flesh when the hills get steep?' and then they were gone as the riders surged forwards, stood on

the pedals and swirled round the next hairpin like a whirl-wind, free of the petty embarrassments of the lower slopes.

There was no shaming. Nobody had seen this manifestation on the Lizarietta, let it be made clear, neither riders nor spectators, apart from Patrul and Jacobi. But at supper in the hotel the whole mood of the team had changed, like there is no autumn, one hour summer, the next winter. Akil sat as if he were slowly chewing stone, radiating chill, and quickly the jokes and the teasing died. Nobody understood why they left the table in grey silence. Nothing, as far as the lads knew, had changed. But the pleasure of the race was over.

Patrul could have waited to talk to his room-mate until they went to bed, but that might be an hour away and after the meal he made a subtle sign to Jacobi who followed him down a passage in the old part of the hotel, through a dark ballroom smelling of trapped heat and unstirred dust, and out to a balcony overlooking a sidestreet lit by one lamp, you know the feeling of a warm close darkness, very old, you get it in some parts of ancient cities.

They leaned out over the musky night. Patrul thought that if they had been peasants, about to discuss a secret matter of the village, they would light cigarettes, and the space around the glowing points, the slow expulsion of acridity into the invisible air, could be the medium of their being there, and the words that passed between them mere modulations of the process of smoking. But they were athletes and did not smoke, so Patrul went straight in. 'That thing that happened this afternoon, with the bandits, did you find it significant?'

He could not see how Jacobi reacted, what shapeless masses of darkness the slow eyes lingered on. Beyond the immediate quiet was the racket of the city, the cars and motorbikes, the TVs from the shuttered rooms above, the human voices far and near. 'Sure,' said Jacobi. It was small result for so long reflection.

'And what is the significance?'

He was quicker this time. 'It wasn't a fan club.'

'So who was it?'

Patrul sensed the young man shrug in the dark. 'They first make mad.'

'Who?'

'Those who the gods want dead. You know that, Patrul.'

Patrul got a cold feeling in his stomach. 'There's no such things.'

'As gods?' Jacobi chortled. 'Never was as far as I know. But there's plenty mad people, nonetheless.'

'And who do you think it is?'

'Not the slightest idea. A rational guess would be, oh, I dunno, Escoto, someone feels Akil's let them down, sold out, wants him to suffer for his misdeeds, thinks he's unstable, like the others; sends in the fun house gang.'

'What others?'

'Oh come on Azafrán my friend. We do not live in rational times. Big frogs, butchery, crucifixion. OK you think we're just the lads, we see nothing beyond our bellies but our cocks. Come off it. There are as many theories as days in the year. You must know that really.'

'And yours?'

'I have this theory – that if you exist at the level of dreams then no-one can trap you. But of course you cannot live your whole life at the level of dreams, and so if I knew, Señor Azafrán, I would tell you. But I don't know who is playing a little game of sending daytime nightmares to our leader, and I suspect I don't have the data for a useful hypothesis. Why trap myself in statements of ignorance. Anyway, you could no doubt inform me of the true state of affairs instead of asking me for baseless guesses. Would that be useful to either of us?'

Not for the first time Patrul was impressed by the intelligence. 'Not now. For now, it goes without saying that none of what happened is to be mentioned, the silly song, nothing, to anybody.'

Jacobi clapped a hand to Patrul's shoulder as he left. It was a gesture of mutual trust. Someday he too might be a leader. 'Good night, Señor Sáenz,' he said as he went through the darker rectangle into the ballroom.

'And is that how you chatter to the boys when the lights are

out?' came Akil's voice, very quiet, from where he stood just within the door. There was something extremely unpleasant about the way he phrased it, Patrul's bosom friend for so many years. Patrul could have snapped back, something equally vicious and destructive, but he was a man of steel discipline and icicle nerve at the required moment.

Instead, 'We can no longer go on pretending that there is nothing out there,' he said. 'We too have to take appropriate measures.'

'Against play actors? Against street musicians, filth hired from the brothels of Burgos?' (There was a strong fascist branch in Akil's family, on his mother's side, and he used Burgos where other people might say Valladolid.)

'Oh, so that's who they were? Who's behind it then, if you know so much – from the brothels of Burgos, who did the hiring?'

Akil came quite close to Patrul and they leaned on the balcony side by side. The filament in the street lamp, a curlicued affair in cast iron greasy with antiquity and canted to about twenty degrees, was obviously in its final moments, and sank to an ever more jaundiced low, sputtering audibly with an occasional pulse of febrile brightness. 'What the fuck are you doing out here anyway?' he asked.

'My question is the important one. Those 'bandits' are out to get you, Akil. You know who's behind it, you tell me.'

'Could it be more obvious?'

'I don't know. Could it?'

'Who else?'

'Come on Akil, stop the fuck wriggling. Who?'

'You boys, do you ever get any sleep?'

Patrul did not need to see Akil's face to know that this was a supernatural answer. Fleischman came between them and put his arm round each of their shoulders – draped level around Patrul's, up across Akil's back like a bandoleer. He smelt clean and fresh and wholesome but as they say, you smell disinfectant, you think shit. Patrul's skin crawled like Fleischman's arm was a snake laid round his shoulders, the hand's rotten breath curling beneath his ear.

Fleischman too had a sense of timing, and he dropped his hands to his sides.

'Mikkel,' said Patrul in a throwaway voice, 'those bandits you paid to come and bother us on the Lizarietta, the ones you hired from the brothels of Burgos to sing suggestive songs about "what does the butcher do with his sausages when he has made them big and fat?" Why did you do that, Mikkel?'

Even in the dark there anybody with a single wit about them could sense that Fleischman was thunderstruck. Very quiet, but thunderstruck. 'What . . . ?' A long pause. 'Let's start from the beginning. Take it slowly. Tell me everything.'

'Well, we were just climbing to a rhythm all very quiet, minding our own business, when suddenly,' and Patrul went on to recount it as it had been, but instead of describing the bandits as they were, he used the descriptions from Gabriela Gomelez's police notes, '. . . these huge men, perhaps two metres tall, it is hard to tell from the saddle, with deep voices, festooned with arms and stinking to high heaven . . .' He could feel Fleischman recording every detail. 'Definitely men?' he checked. 'All three? Tall?'

'Machistas from the sierras of Extremadura,' agreed Patrul, 'built like trolley buses.' It was clear that Mikkel hadn't a fucking clue.

'What was that about from the brothels of Burgos, Patrul?'

'That's Akil,' he said smoothly. 'Akil thinks that everything that stinks comes from the brothels of Burgos.'

'Filthy fucks,' grated Akil.

'And you would corroborate Patrul's account? Is there anything you would wish to add?'

Patrul's heart rate upped to 150 on the beat, but Akil did not betray him. 'Filthy fucks,' he repeated.

'I need to give you something tonight, and then you need to sleep. Come on Akil.'

As Fleischman led the greatest bike rider in history out through the pitch dark ballroom, Patrul called after him, 'It was sure disturbing, Mikkel, after Sarpedón and all. Akil upset, *I'm* upset. Why'd you do it, Mikkel?'

Fleischman came back to the balcony, leaving Akil standing

in the dark like a child. 'Patrul,' he said, 'when I find out who did do this thing . . . nothing is more important to me than Akil's peace of mind. You and I, we are key players. The three of us, we are locked in a ring. For you, Señor Azafrán, I have a great and genuine respect,' and he picked up Patrul's fist and kissed it.

'Your fucking ring,' thought Patrul as Fleischman led Akil out the other side of the ballroom, 'not mine, matey.'

From then on Akil rode in the shadow, but he rode unvanquishably. No more playing. The next day was a big Pyrenean stage, over one col, then another, finishing on the third. At the top of the second climb Peluso was a minute and seventeen seconds up, then came a bunch with, as well as Carabuchi, Tiss the new generation of climbers, Keino, Moyo, Ebola, Todden, al-Udin, Cavouga, Dollar-Ogo. Riding at the front of this group, his last Tour, modulating it with all his accumulated wisdom, experience and strength, respected by all, was Azafrán, and always close to his wheel, sheltered from the wind and disquieting changes of pace, the stone faced Akil Sáenz.

At the top they made the classic move. Sáenz went to the front, Azafrán picked up his wheel and they banked into the first downward hairpin on the limit of adhesion. Carabuchi, next in line, knowing exactly what would happen, that at the extreme point Patrul would deliberately lose Akil's wheel and let him go, tried to go round the outside of Patrul but Patrul, while never for a moment bending the rules or the unwritten code of honour without which cycling would no longer be sport but gang warfare, drove him towards the edge of the precipice, touching the brakes with a feather meanwhile. Carabuchi and those behind him had to brake or die, and suddenly Akil was fifty metres down the road. That was the end of the Tour as a race. He caught Peluso on the descent, and by the 1900 metre ski station at the end of the final climb he was leading the race by three minutes and thirty five seconds. On the podium he took the yellow jersey like a Caesar taking tribute, a Caesar who had never smiled in his life. From there to Paris he defended his lead with unbending

gravity. Whereas the first half of the Tour had been designated by respected commentators as the most frivolous in the history of the race, the second was universally dismissed as the most dour.

Akil's latest and most magnificent contribution to cycling history, the only rider ever to have won six Tours de France, was met with no true celebration. There were speeches, banquets, citations, honours, sure, but no high spirits.

Cosimo held a memorial dinner which every team rider was instructed to attend, wearing the team blazer. The dishes looked like all the culinary riches of the world but tasted like junk food before the flavours have been added. The chairman of the conglomerate made a speech proclaiming that in sport the human spirit, its will, its ingenuity, its strength found the highest form of expression, and everybody clapped. Then Mikkel Fleischman made a speech in which he said that while sometimes sport got a bad reputation for abusing the bodies of athletes, this present triumph of Akil Sáenz – and he was sure it would not be the last – demonstrated that correct nutrition; training scrupulously based on state of the art theory and finely modulated to the biometric feedback from each individual rider; and above all a holistically caring, supportive and positive team environment; could achieve results far beyond the application of complex chemicals which had no place in nature. When he had stopped speaking everybody clapped again – the Chairman of Cosimo Pharmaceuticals rather stiffly, to be sure. Then it was like the church service was over. Then we all went home.

Stage 22

There had been a bomb in the city during the San Sebastian classic. It had not interrupted the race, but a tourist kid with half his face blown away, maybe that's what had upset Akil. This is not said with callousness. No child should suffer, from the condos of Miami to the camps in Zaire, no child should suffer, that's how the world should be. Given that it is not, there is the question of why a child with its face blown off in the next street should be more disturbing than one that steps on a land mine in Angola or is gassed in the Ante-Taurus mountains. Akil was not one of the ancient people of those parts. Nor did he give support to any political party. So, not guilty, that was the factual situation. Nonetheless he was upset. He said it could have been his own child, the baby Iridacea. But it wasn't. That's all you can say. It was another child. There are billions of them.

He did not hear reports until he had won the race and received the prize. Then when he had been told, in the shower, he said to Patrul, 'We get out of here,' dressed quickly and waving away Fleischman, the reporters who wanted his views on the Separatist Movement and whether it was justi-fied to target sport for political exploitation, and swarms of autograph hunters, he folded himself into the Diablo and snarled home. Azafrán in his supermarket estate – the only motor vehicle that Patrul really trusted was a tractor – arrived half an hour later and Akil, Perlita and little Iridacea were ready to leave the house, so they piled in and Patrul drove back down the road and across the river to Los Alcornoques. This time they asked for an alcove room where there was some privacy and a ledge along the back wall for Iridacea's carrycot.

'The hour has come to talk,' Akil announced when the bread and wine and fish were on the table. Beyond the alcove the Saturday night diners were less noisy than usual, out of respect for the bombed. After he said that he was silent.

'Why?' asked Perlita. Not 'What about?' but 'Why?' It was a useful question.

'I have been betrayed for a mess of potage.' This meant nothing to the other two, but the fascist element in Akil's family had naturally left a residue of sound bible knowledge. Anyway Patrul thought a mess sounded about right. 'Betrayed by who?' he asked.

'Always, of course, myself. Each person has to be at the centre of their own betrayal, you can only be betrayed where you are utterly committed. Otherwise it's just a trick. Betrayal, you let a person into your sacred places, knowing their very purpose is to pollute. Then, when the shit hits the altar, you lament. To be betrayed is just a cowardly way of suicide.'

'Bollocks.' The gobbets of religion gave Azafrán a sinking feeling.

'And what would you know?' Akil said it like to a child who has experienced no adult tragedies.

'Hey guys,' chipped in Perlita, 'good hake here. Lighten up, huh?' Akil turned to her like she'd just suggested torturing the baby. 'OK,' she sighed, 'what's on your mind?'

'Nothing. Nobody told me there would be nothing.'

'What do you mean, nothing? You say the time has come to talk. What are we going to talk about? Nothing?'

Patrul, the calmest, the most understanding and benign of men, suddenly lost his temper, he didn't know where it came from. 'You snivelling cretin,' he said, very quiet, very tight, 'you sell your soul and then you squawk. You buy a car, you expect to have more money in the bank? You drink your wine, you expect to see it there in the glass? You gamble away your house and then go home to sleep there? He who fucks with the devil, my friend, needs a ceramic arse.' This last, he did not know why he said it. It is not an ancient proverb. Ceramic in this sense is a space-age material. Anyway it moved things on with Akil.

'Oh, so you join the motherfuckers of Burgos in their screeching, do you?'

Perlita turned to Patrul with a cute uplifting of the eyebrows, like she was a Colombine. It seemed Akil had not told

her of the bandits on the Lizarietta. But it was not Patrul's position to fill her in now. So she turned to Akil. 'Come on,' she said, 'out with it.'

'It's best you know nothing,' he said. 'Sometimes you are on a path long before you know it. You think you are just walking. Things in the distance look interesting. You go a long time, and then you look down and suddenly you see you are on a narrow causeway through a terrible swamp. You turn around, but the track behind you has dissolved into the filth, you look ahead . . .'

'Sure, sure, sure,' said Perlita. 'Who are the motherfuckers of Burgos?'

'If you knew – if you knew too Patrul. If you had known, that thing you said about fucks with the devil. There is a truth in that that you could not suspect.'

'Try us,' said Patrul. 'I think you may be under some illusion here.'

'My one comfort is that I have been alone, yes, always,' he nodded as if checking out one or two marginal occasions when he might have been vaguely accompanied, but found to his satisfaction that this had not been the case, 'alone as far as my memory goes back.' Perlita made to contradict this, but Patrul slightly moved a hand for her to let Akil continue. 'OK, you can't understand that. That's why I'm alone. If you could understand it, then I wouldn't be.'

'And if you weren't, then there'd be nothing to understand, so I wouldn't, so you would.' But before Perlita and Akil got into one of their completely meaningless arguments Patrul brought it back to the real world. 'Akil my friend – the question comes in two parts. Here you have your two most caring and I would dare to say your closest friends. Part one is, do you think there is anything significant we don't know about your situation? And part two is, if so, are you going to tell us?'

'I don't think you know anything about my situation. You have no idea what the price was. You know what the reward was meant to be; the most famous, the greatest, a name inseparable from history and cycling itself. Yes. It is so. But is it me – not is it Akil Sáenz – is it me when I get up in the

morning, when I clean my ears, when I go down to the shop for a newspaper, when I scratch my balls, when I go to the café for a cup of coffee, when I watch the news on TV and see there's been a bomb, when I kiss Perlita, when I cuddle my baby? That should be me; and the photocalls and the sound-bites just wrapping round emptiness and nothing. But I've been turned inside out through my own arsehole, man. He didn't say he could take the daily bread away like that and leave only the promised land. And made even my body a shameful thing. You have no idea how shameful he has made my body.'

'That? That's nothing. Think what it would be like if you had cancer of the colon.' Again Patrul did not think before he said it. He was just trying to get things moved on.

Akil looked as if his viscera had been sucked out by a sludge pump. 'What do you know?' he shouted so that Perlita laid a hand over his mouth in warning that the situation was not socially cool. And at that very moment Fleischman came in through the curtain.

It cannot have been true that he was passing. The road to his home 1500 kilometres away lay north of the mountains. But it showed the capacity of the man, how did he know to find us there in the haven of Los Alcornoques when we had not even planned it ourselves. In addition the human capacity for self-deception is remarkable. Patrul was beginning to realise that Akil really did believe his condition was secret.

There were a couple of spare chairs and Mikkel took one. He ordered more wine and just some bread and spiced saus-age of the region. Perhaps he had been listening outside the curtain, but that would have been hard, because the waiter's shadow came and went upon the cloth, and Patrul had been vigilant. Mikkel smiled round. The hyper-clean lenses of his glasses had a mauve interference film. For a moment they seemed to Patrul like mirrors reflecting Akil's eyes. Iridacea woke and began to grizzle. 'May I?' Mikkel asked Perlita, and rose like an energetic feather and took the child from its carrycot. She was immediately quiet, and he ran an eye spacious with knowledge over her little frame, feeling the

160

forearms, running a finger down the legs, looking into the eyes. She had started to smile properly, and Mikkel was clearly delighted by the beaming reward for his attentions. 'Perfect,' he said and then looking from Akil to Perlita, 'but why should she be otherwise.'

'Give the child to her mother please,' said Akil. It was as if he were talking to a subhuman, but Fleischman lightly did as he was asked, and Perlita opened the front of her dress and Iridacea immediately began to feed. 'You don't mind?' she asked Mikkel, smiling.

'Oh come on, Señora Sáenz,' he grinned, 'man born of woman. They fill me, if you want to know, with an over-powering sense of gratitude. It almost makes me cry.'

Perlita tossed her head and winked at him, smiling a smile that was not a smile of friendship. 'But I'm not Señora Sáenz. I am de Zubia.'

'Well that's sorted that out.' The food and drink arrived and when the waiter had gone Fleischman made a quieting gesture as if he was opening a contentious meeting and said, 'I think it's high time we four had a little chat.'

Patrul couldn't see that that was such a good idea. 'I thought we had a little chat in July, during the Tour.'

'But Señora de Zubia wasn't with us then. I just wanted to make my view of things clear. My view of things is that we are all now equally in this up to our nostrils. Anybody at this point who tries to evade their responsibilities is merely betraying the others. There is always a penalty for betrayal. Of course it goes without saying that I am not threatening here. Judas, for instance, the Judas of Christian iconography, nobody had to threaten him. He hung himself and, as I recall, his guts spilt out upon the ground. Strange physiological detail, that, not the usual result of hanging.' He raised a sardonic eyebrow at de Zubia, who had no idea what he was talking about. 'Anyway, what I mean is, if we go down, we all go down together.'

'Each to his kink,' quipped Patrul, 'but not for me.'

'Oh yes, for you too I think. Tell me,' Fleischman turned to Sáenz, 'how do you feel now that you know your best friend

has been spying on you, that he has been aware for some time of exactly the, er, procedures which we employ to enhance your performance even above the elevated level of your natural talent. You see Akil, these motherfuckers of Burgos – mere play-acting Bandits,' he explained dismissively to Perlita, 'singing a childishly suggestive song about sausages – if you thought about it Akil, it was very clear that they were nothing to do with me. To me the necessary procedures are purely a matter of sports medicine, and as you would know if you had taken the slightest trouble to understand my own position and my own psyche which, however, not being the sole source of your obsessive interest, that is, yourself, you did not; if you had spared a minute's thought for me, you would realise that such procedures cannot possibly be shameful, but rather a matter of celebration . . .'

'You pollute me with your perversions,' spat Sáenz, demonstrating that if he wasn't capable of emotional insight, he could at least follow overcomplicated syntax.

'I do realise that that is a point of view that seems to have got rather a strong hold on you over the last few weeks. Which is why it is incomprehensible to me that you should think I would go to the lengths of hiring actors to taunt you on some little Pyrenean slope.'

'Well who the fuck else would? Who else despises me to that extent?'

'Let us not for the moment go beyond the extent of this little room. As you also probably don't know, one of the great joys of my life, the painting of the epoch of El Greco. Old masters, you know, what themes, the crucifixion, the pietà, the last supper, yes the last supper.' He smiled around. It was a smile empty of all affection. His mind was obviously on larger things. 'The Magdalene. Nobody seriously thought she had betrayed her Lord. The doctor, Luke . . . ?' He shook his head, 'for reasons that I have already made clear. So, thirty pieces of silver? No, not even thirty pieces of silver. But what? I don't know. Jealousy, envy, a desire to drag a god down to the level of sweat and shit of a mere *équipier*? Who can say. What do you think, Patrul?'

Patrul for once knew when to say nothing. Akil was already poisoned. There was a sombre silence in which only eyes moved. Then Fleischman said, 'I must go. I have a long drive tonight. Heathrow, Monday, 11.20, Akil. Señorita, adieu. Pass this on would you, Patrul?' He shovelled a few silver coins onto the table, rose and bowed, and stepped out through the curtain. The wine, the bread, the thick sausage lay untouched.

Stage 23

Galaxie-Cyclasme comes out on a Friday. The issue that hit the stands in the first week of the Vuelta de España carried a made up story, a piece of worthless and despicable fiction. Its mendacity occupied itself with two one-time friends, the world champion racing cyclist and his faithful lieutenant. The world champion – and here the story in a filthy sneaky underhand way suggests the writer knew something about the difficulties between Sáenz and Azafrán – begins to hate his friend with an overpowering hatred. There is some deliquescent crap about a Nazi chemist, a laboratory, human experiments, and the result is that the champion, when he and his lieutenant are leading a big race, draws from the bottle cage a bidon modified as a missile launcher and shoots a high velocity toxic suppository straight up his fidèle équipier's arsehole. This made-up story was entitled *Bidon of Blood*.

It was Jacobi who brought it to Patrul in their room after supper on the evening of a difficult stage in a difficult race. Akil was in as strong a position in the Vuelta as he had been in every race that year. He wasn't leading, not making any excessive point about being the best in the world and fuck everybody else's feelings, et cetera. But he was within easy and relaxed striking distance of the leaders.

The trouble was he was now refusing to talk to any of his team in anything but one word shouts, and refusing to speak to Patrul at all. In fact he behaved as if Patrul didn't exist. He did this logically and consistently. He acted exactly as if the space taken up by Patrul and his bicycle was an empty space, and therefore a space he himself could take up without a moment's warning. Any change of pace or direction from his team leader when he was close, and Patrul had to react instantaneously to get out of his way and avoid a collision. It would have been demoralising behaviour from anyone. From his closest friend it was deep humiliation.

And then *Bidon of Blood*. Jacobi didn't lie on the other bed as Patrul read, but sat on the small table with his feet on the chair, and slowly scanned Patrul's face as if the words were reflected there. From anybody else Patrul would have found this annoying so he would have shouted at him to stop, but he needed a friend now, and Jacobi he trusted to be doing things for good reasons, even staring. When he had finished he looked up. 'It's bollocks,' he said.

Jacobi's eyes went down to his feet, then swung slowly over the carpet, climbed the drawn curtains, traversed the wardrobe, moved on upwards to the ceiling and then slowly swung down to join Patrul's own eyes. He was not quite smiling. Then he did smile. Then he shook his head. 'I'll be watching out for your arse,' he said, slid from the table and wandered out the door.

Paranoia is when your enemies get your mind to do their dirty work for them. De Zubia was at home, following the race on TV and looking after Iridacea. Immediately Jacobi left the room Patrul typed a note on his laptop and sent it to her, using the encryption card that Gabriela Gomelez had slipped him in Lens.

Hey kid, Read that junk in G-C? They don't care any more who sees them. It's crazy. That's for me that is. What do I do, just run? I can't, I got a race to ride. Not that I want to be a hero, believe me, but I have a contract. I can't afford to do the sensible thing and run like hell. Could you get onto the guys and see what they suggest. A huge embrace. Your Friend.

Perlita contacted Gabriela at once, and a meeting was suggested. The very next morning she strapped Iridacea's seat into the Diablo and drove down to Andujar. With the little brown girl burbling away beside her she had temporarily lost the necessity to achieve 250 kph, in fact she rarely went above 100. Before she left Andalucia she relayed the following to Patrul from Detective Inspector Gomelez:

He will need you in the Worlds. I think you can
probably relax until then. I long for your body
as I long for chaff in my bread and gristle in
my meat. An embrace nonetheless, for none of us
can much help what we are, Gabriela.

The next morning as the peloton rolled out of town, Patrul
felt like the child at school who everybody has decided not to
talk to. Only Jacobi rode at his side from time to time, chatting
as if nothing had changed. He never seemed to notice when
he had to take sudden evasive action as Akil Sáenz, moving
into what was not a gap at all ready to take off after this or
that challenger, made Azafrán squeeze to the side rather than
topple his friend and team leader to a rightful mêlée of
grazed flesh and buckled metal.

There hadn't been a cycling death for nearly a year. It was
the time of valley mists and the first snows in the high moun-
tains. In the woods the rich green of the leaves was darkening,
and they clapped together in the moving air. The Worlds was
near.

<p style="text-align:center">★</p>

It has perhaps not been emphasised enough how great Akil
Sáenz's achievement was that year. Other things have over-
shadowed it. Yet measured by dull statistics, races won, records
broken, mountains climbed virtually alone while the pack still
creeps along the valley below, it is without parallel. There are
the top professionals. Then above them are the giants. These
are names that, wherever you go in the world where cyclists
meet, will come spinning off the tongue as ordered as the roll
call of the saints – Coppi, Anquetil . . . And as high as these
champions of the world are above the merely hugely talented,
above the, as one might say, Poulidors or Kellys, the Azafráns,
so much higher again was Sáenz above them.

The traces of this greatness are there in film and video, but
they are almost as thin as memory. Just perhaps in two or three
paintings, the recording of the commentator's voice breaking
with emotion as he tries to convey a power and endurance

which one cannot believe even as it unfolds before your eyes, perhaps there you feel in your blood a momentary shiver of the spirit which so uplifted the world. The most haunting portrait is not of Sáenz on a bike, half-likenesses which emphasise sweat, speed leaning against gravity, the individuation of muscles under huge strain forcing crank and chain wheel, the narrow tyres slicing across the black furnace of the road, veins knotted along umber forearms, the face a lacuna of suffering blanked out by naked concentration, the strident hue of the Cosimo jersey – the usual run of trite sports painting which represents men in racing cars, on racing motorcycles, men playing football, playing basketball, whacking golf balls, playing snooker even – all with the same boys' comic-book hysteria. No, the painting that gets it best is unsigned, probably not by a trained artist but by an amateur done with talent and adoration. It shows just the face and hair of Akil, and for an amateur it achieves the disquieting mauve gaze with understated skill, looking down and out across the Alps from Mont Ventoux.

*

So now to get to the truth. Galaxie-Cyclasme, what do they know? Fuck, excuse me but fuck, it is no skin off the nose for me, but to see a good man traduced, a man like Patrul Azafrán, it would be dishonourable not to put the record straight. What do they say? That he tried to lose his *patron* the race, that then as his *patron* lay brainless on the podium, Azafrán, a coward they say, and a cheat in every way, escaped with the dead man's wife. *Patron*! These French, what do they know of friendship or honour? So I, a bystander and an honourable man, no more, tell all I know.

Which is not all. Who was trying to kill Patrul Azafrán as the World Road Championship ran its course, of that there can be no certainty. In truth, that any rider was trying to kill his fellow during that race, there is not even proof of that. But what Azafrán knew was that there had been a vile made-up story in a garrulous rag. Well, is it a thing to be astonished by, or disapproving, if Azafrán started that race with the

possibility in his mind that Akil Sáenz was going to try to kill him by shooting a ballistic suppository from a modified bidon through the lycra and chamois and up his arse with the result that within an hour his flesh should fall from his bones in dollops? I mean sure it's all very well after the event to say that the whole thing was impossible and ridiculous, but one may be permitted to pose a question in return. Given the events that had gone before, how is it that Patrul can be sneered at for taking seriously the possibility of this particular perversion of murder?

One gets excited – but when one sees an honest and just and courageous man vilely slandered, one has a right.

Also, the Worlds that year was not like it had been before, a normal road race round a circuit in a normal place like Colombia or Switzerland or any usual location like that. Lac Cul d'Avenir was a new sort of place. It was a complex among the mountains where the already hugely rich and healthy could come to stoke up yet more on the world's involuntary generosity. Clinics were there not in their twos and threes but in their malls. Ass's milk and foetal jelly – they never called it that, but otherwise where's the magic?

Much of it was conventional, that race. But the start and finish went straight through the Temple of Holistic Being on top of Mount Igfuane. This Temple of Holistic Being was not the new age shite it sounds like, but commercial in the spirit of the place. For instance one of the main exhibits was the human genome, but with each gene encased in a transparent representation of the Corporate Headquarters which owned outright that particular fragment of humanity. I just give you that detail to stand for the whole.

Along the start/finish straight they had something particularly crap, models of the great bike racers of all time, from the start of the Tour de France near the beginning of the century to those just dead, riding along, pedalling models of authentic contemporary bicycles. These were not holograms as one would expect in keeping with the venue. Instead the designers decided that the Dortignacs and Bobets, Burtons and Ocañas should be as solid as flesh. Thus a hundred or so not quite

super-real enough latex-moulded robots with all the major muscle groups perfectly articulated and in emphatic flesh tones traversed the straight beside the living coureurs. But what was especially horrible about it was that at the end they disappeared behind a barrier and dived into the ground. So you knew as you rode like fuck in one direction that they were riding like fuck in the other, upside down and under the earth. It gave you the bad feeling of a ghost train or a crematorium.

You burst out of the Temple of Holistic Being into the open air and straight onto a technical descent. By technical they mean you got to exercise a little discretion with velocity and attempts at deceleration so you don't dive over the side or scrape the bony bits along the tarmac. Then you're into the fast section of the course, first through a forest, gentle up and down and smooth curves, and then a turn to the north-west and along the lake. The mountains the far side drop into the water in steel blue cliffs with jagged rocks, but you don't have much time for sightseeing because here every day the wind is behind you, so it's flat out on a big gear to get to the bottom of the climb first. This ascent goes up with the cliff from the north shore of the lake. A few kilometres and a dozen hairpins later is the summit, the Chaise de Diable, where the one road into Cul d'Avenir enters from the west.

And then the interesting bit. From the Chaise de Diable, drops, plunges, precipitates the innovation that gave the race a new feeling of shocking extremity. It's a strange one, this, it's like a fairground ride more than a section of a serious road racing course. 'If we'd wanted to be trapeze artists,' said Stongo, 'we'd have come in our fucking sequins.' Officially they've named it La Redondez Compleja but some riders call it the Devil's Dick. The old road snakes down the 130 vertical metre descent, but above that has been erected on a scarily delicate frame of steel and kevlar a banked triple curve on a 20% drop. Now this really is technical. Talbali, who suffers from vertigo, had one look at it and pulled out of the race rather than go down it on a bike. There were several other riders who never even conquered its minimum demands, and

packed before the first lap. But for descenders of the quality of Sáenz and Azafrán it was a glory like flight. You could burst up the Chaise de Diable, slip right through to your highest gear at the top and for a couple of seconds relax completely, hit the zone; fall like a stone till you touched 120 kph, roll clockwise and surge with the rising g-force to the very top of the banking in a right-hand curve; as the curve straightens you dive in a swoop like from rooftop to cobble to rooftop again across a ravine, not street shaped, but hyperbolic, to the rim of the right-hand banking, hurtle left, a second dive and climb across the hyperbola, a final 2g bank to the right, and a short straight in virtual free-fall before you flare and land back on the planet, on the stone and bitumen of the solid earth.

The structure looked like twigs and spider web but in practice, even when a bunch of twenty guys was going down and did the swoop from right to left and back again bar to bar, elbow to elbow, giving no quarter, even when it was taking those forces, nobody ever complained they felt the structure move by a millimetre. Oh, the other thing about La Redondez Compleja – the track itself, the banking, was fabricated from translucent polymer as clear and smooth as glass, with only fine black lines etched on it to show its shape and limits. Under your wheels you could see the sheer drop to the rocks of the mountainside. Spectators thronging on each side below the banking looked up to the riders as if they were beneath a transparent earth gazing through the surface of the track.

As you hit the old road you have to brake because there's a rock in the way, La Baratte, the road bends hard left and right round it and there isn't any computer designed banking to help you. Then there's a flat section of a few kilometres, another burst of speed, and you're on the climb back up Mont Igfuane. Again the climb is only 191 metres, such as any cyclotourist wouldn't think twice about, but what you got to take into account is that by the time fifteen laps have been completed and the race is finished, the riders have been in the saddle for more than seven hours, they've covered 268.5 kilometres, and they have ascended more than half the height of Mount Everest.

OK so Patrul could feel guilty for what Galaxie-Cyclasme called 'tactical insanity played first as low farce and then yet lower, as the derangement of cattle'. But did not Azafrán have every reason for his paranoia? Shit, Akil hadn't talked to him for fifty four days.

There was something else, and Patrul could see how it might have looked to the journalists, the tens of thousands in the crowd, to the millions across the world watching on TV. With Akil Sáenz beside him on the penultimate ascent Patrul – knowing by then that what he had to fear was elsewhere – Patrul had the sudden, clear realisation, dreadful and comforting at the same time, that he himself was but an ordinary man, climbing in the shadow of a dying giant. You may say he was a bit slow to notice. Shit, Akil hadn't talked to him for fifty four days. And the threat had not gone even when he did notice Akil's weary dependency, the hurt of an abandoned child, that's almost how it seemed, a child whose father would not carry him, how to understand such cruelty.

But the new threat was storming up Igfuane behind them, and Patrul had to get away. At the time, it was in the category of the absolutely necessary.

So he had misinterpreted Akil from the starting line. He had misinterpreted Akil's smile. As well as not talking, it was fifty four days Akil had not smiled at his friend. To Patrul the smile when it came looked like the hiss of a snake.

And then the final *atropello* that put him on edge. The start went straight into a crash on the first descent of the Igfuane which resulted in a cracked tibia and two broken collar bones for minor riders. That was nothing. That was how the young learn to be watchful. By the time they got to the top of the Chaise de Diable the race had, because of the crash, split into three; a lead group of tearaways half of who wouldn't last the distance; a group with all the serious contenders apart from Villeroni, who had damaged himself in the first *chute* – a group which included Sáenz, Azafrán, Carabuchi, Tiss, Gestalt, Lostwithiel, de Vega, Peluso, Lorca, Jacobi, Calderón &c; and a final group of the nervous, the slow starters, the bronchially challenged and the plain idle.

This group hit tragedy on the first descent of the Redondez Compleja. A wide-eyed kid, du Cygne, having gone over the top and into the banking with élan, looked down through the glass and suddenly it's the wrong bit of his brain telling him he's canted at seventy degrees from the vertical and flying though the air with nothing apparent to support him but a blur of finely etched black lines. The wrong bit of his brain made a suggestion as to how to get out of this situation immediately. Stop, it screamed. Du Cygne hit the brakes. The result was a massacre – nothing fatal, but a lot of – uh, it was really shocking seen after on the TV – heat burns that seared the skin black on the near invisible gloss of the surface, and many severe contusions and much mangled metal at the hyperbolic zero. Lucky only the tail-enders were involved.

After that carnage they stopped the race and cleared up the mess, then started it again from lap two with a depleted field. From then on the technical side went smoothly, and Patrul could concentrate on keeping Akil off his wheel.

It's strange how your mind is set. Even when there was a fairly clear indication, he didn't notice. The one part of the course that was free from danger was La Redondez. Such was the speed and the requirement for relaxed but total attention that it was impossible anybody should try any funny business here. Here for whole seconds he could rest, while he let his body and the bike curve through the path that the computer had ordained. Perhaps it was this sense of giving yourself to a superior and irresistible power, but when on the second and third laps Menaleon had come out of zero gravity on his wheel and ghosted up onto Patrul's left shoulder before they had to brake for La Baratte, Patrul's deductive powers had momentarily lapsed. Sure he had noticed the bidon in Menaleon's right hand, sure he had thought it was a bizarre place to take a drink, but as a source of danger, somehow it had failed to strike him. Instead he'd guessed that Menaleon was calculating a way of running him into the rock. After all, that is what Patrul had done with Menaleon in April and this was his first big race since his bones had healed. He had come

back, it seemed, well rested, fresh and on form. Practising for his symmetric revenge, that's what Patrul assumed.

It was the sixth ascent of Igfuane. The race was settling into its mid passage, attentive, rhythmic, waiting for signs. Calderón and Lorca were up the road a few hundred metres, but nobody expected anything to come of it. All the riders who remained were in a loose group spread out over a couple of hundred metres. The national team of Sáenz and Azafrán was near the head with a mixture of other riders, commercial team-mates and companions. At this stage the climb was not so much contested as felt out. One stood on the pedals in a smooth and flexible way, and asked rivals sincere questions about their investment portfolios which they would have to answer without it being suspected that they were at a loss for breath. This, it may be pointed out, climbing at a speed which most recreational riders couldn't maintain for ten seconds on the flat in still air.

Suddenly, a few hundred metres from the top, Sáenz swung across three riders in his imperious way and surged in on Patrul's shoulder.

'Patrul,' he said intensely, 'Patrul Azafrán,' and then he went on in the deep patois of their home region, so that not even our countrymen from the big cities might understand, 'forget the past.'

'Forget the past!' Patrul sneered – yes, it has to be admitted, he sneered – 'Here we are at Cul d'Avenir and you tell me to forget the past. What else is there then, my one time friend?'

By now they were on the straight that runs through the Temple of Holistic Being. The past, or its garish likeness, the latex simulacra, Buysse, Pélissier, Heusghem, Scieur, others unknown to Azafrán, pedalled mechanically alongside.

'Only "now",' said Akil, 'that's all we ever have. Listen, from now on you must ride for me and think of nothing else. If I do not win this race, then all I have done so far will be ashes.'

'I couldn't give a fuck,' said Patrul. It wasn't totally true, and though they were into the technical descent and they were braking, leaning round the next 180 degree reversal so

steep that their pedals kissed the dust and their wheels lay over each other like plates drying in a rack, edge to apex of the hairpin and swooping out to precipitous edge again – although all this needed their attention, Patrul looked across to Akil when he said, 'I couldn't give a fuck,' in a way that might have been taken as regret that things were so.

'Anyway,' said Sáenz, 'it is also necessary for your safety that you ride for me. If I stay on your shoulder we both survive. If I do not . . .'

The road levelled and widened. Patrul was in confusion. 'We both have enemies,' said Akil. 'For instance, Menaleon would not be sorry to see you dead. And there is hardly a rider here who wouldn't take a little secret pleasure in witnessing my humiliation.'

'Me for one,' said Patrul.

'Look,' said Akil, 'I'm not theorising with you, I'm telling you, if you don't ride for me now, you're dead meat. I tell you this as a friend who knows things that you need never know. I want you back, Patrul, now – otherwise . . .'

Dead meat. It's only an expression. It could for instance mean your career is finished, that contracts for next year will be with Colonne Irriguée or nobody. But dead meat – he didn't like Sáenz being that close to him. 'Show me your bidon,' he said.

'What?' snapped Akil.

'Your bidon. Both of them. Give here.' Patrul would be able to tell by the weight if either was, not a drinking bottle, but a missile launcher.

'What the fuck for?' said Akil. He sounded sincerely taken aback.

'So I can check, make sure. You've read the fucking Bidon of Blood shite as much as I have.'

The responses that Akil made were not satisfactory. He suggested first that Patrul was mad and then that Patrul could not be trusted, that perhaps he wanted to contaminate the bottles, something smeared around the valve that would cause extremes of diarrhoea, projectile vomiting perhaps.

So Patrul told Akil that he was totally deranged, what the

fuck kind of person did he think Patrul was — a friend who had been abused and humiliated before his fellows by the arrogant extremes of Akil's behaviour, sure, but a man of total honour nonetheless, not the kind who would ever stoop to the level of other people's arseholes, who would for a second contemplate such loathsomeness as poisoning, which, it made his spirit suffer to say this, people who he at one time trusted like a brother seemed to have no trouble trading in, the sickness and the death.

At this just commentary, something snapped in Akil, and in one movement he drew his bidon from its cage and slung it at Patrul's head. Journalists have talked of low farce, of heroes descending to the level of lady greengrocers, but what do they know of tragedy? Patrul was quite sure that what was coming at his head was an organic vileness, and he ducked low on the bars as the bidon slugged into a tree and burst behind him, nothing but isotonic drink. The blow struck to his nose by the handlebar stem caused some loss of blood, yes, but the constitution of an Azafrán is not diminished by trifles.

Tragedy apart, it has to be admitted that this was not the way to conduct a race on the fastest part of the course, and while some sat up with their hands on the tops and enjoyed the show — even though the language was obscure to them, the depth of feeling expressed was not — others made calculations. These others decided the race could be won and lost in this moment, and the most powerful of these on the day was Jacobi.

As Patrul raised his seeping nose and a great rage went through him at the pain, he saw Jacobi streaking up the road and into the curve that swings with the wind up the south eastern shore of the lake, with seven or eight riders in pursuit.

It was an answer to his fury and confusion. He hit the pedals like a lion and accelerated with all his strength. Akil, close to tears, did not respond. Instead, it was the reptile Menaleon that got on Azafrán's wheel.

Patrul rode like the devil then. Sometimes even with indifferent riders a superhuman strength comes from nowhere, and they can with ease, for an hour or a day, outpace the mighty.

Azafrán is universally acknowledged to be far more than an indifferent rider, and hauling Menaleon like a shitten tail behind him he caught the breakaway group on the Chaise de Diable, flew with them down La Redondez, and by the top of Igfuane he had them struggling, three already gone off the back like chaff. On the descent he lost two more, terrified by the lethal velocity with which he hit the bends. Then through the soft curves and gentle undulations of the woodland he settled into an easy thunder of barely constrained power. He was towing the break, Jacobi, Menaleon and four others further and further from the bunch – and this was no escape of boys frantic for a moment's fame, this was a real threat to he who had it in mind to be Champion of all the World. So what was he up to, Azafrán, what were his tactics, how was this contributing to his duty as *fidèle équipier* of the greatest rider the earth has ever seen?

Azafrán can only say in his defence, and with total justification, that such questions were not at that moment at the forefront of his mind. There were others. On the next ascent to Le Chaise he had blown away all but Jacobi and Menaleon, so just those three howled down La Redondez like dive bombers in tight formation. They hit the road at the bottom in the order Jacobi, Azafrán, Menaleon, and worked together, each suffering the lead for ten or fifteen seconds before peeling aside, drifting back, taking the wheel, resting, cruising – as runners in the 100 metre sprint cruise the middle third of the race.

At the bottom of Igfuane Menaleon came from third spot close onto Patrul's shoulder. 'Now I've got you, you half pint twist of grinning shit,' he hissed, drawing his bidon, waving it in Patrul's face before clunking it back to start the climb.

It could perhaps have meant nothing. After the story in Galaxie-Cyclasme, it has to be admitted, waving bidons at people had become a bit of a joke, a sick one in Patrul's opinion. There are those who say Azafrán was overreacting in his fear, that he was prey to a womanly imagination. What kind of insult is that? Have these journos not yet learnt that to disparage women is no longer macho but the symptom of a

diseased libido? Who at any rate under the circumstances would allow such a man to sit on his wheel? Not Patrul Azafrán.

The trouble was that Azafrán and Menaleon were in the same national team, and Jacobi was from another country. So the correct tactics, and those which would support Sáenz, would have been for them to impede Jacobi as much as they could, sitting on him, harassing, never letting him get a rhythm; but the quarrel had already put paid to that. Now Patrul's instinct for survival told him he should never again get into a position where his arse was within Menaleon's easy reach.

Menaleon was very fast that day, but he was not race proven. Patrul reckoned that his only surety of not getting the fatal pellet up his rectum was to get Jacobi onto his wheel and then either burst his heart or escape his persecutor. 'What perfectly formed buttocks,' simpered the dung beetle, 'how they will drip off the bone,' stroking the bottle the while as if it were a bloated dick. Patrul could stand no more. For the second time in the race there was a real surge of rage and adrenalin, and a hundred metres from the top of Igfuane he accelerated like a pouncing leopard.

His strategy worked. Menaleon, strong as he was, but incited by malice, did not have the pure will to sustain such a pace. Jacobi, whose faith was pure and whose heart was set on nothing more sinister than victory, leapt at Patrul's irrational generosity. As they went over the top and along the straight the huge crowd could not make out a millimetre of light between his front wheel and Patrul's rear. But Menaleon sat up like the woman he was at heart, and waited for the bunch.

On the flat kilometres of the course Azafrán and Jacobi worked together like brothers. They were after all for the rest of the year team-mates and room-mates, and so brothers was in a sense what they were, eldest and youngest.

Soon Escoto, who was manager of Azafrán's national team as well as QiK, drew alongside them and leaned out of the car window. He roared at Patrul – and this was only the second time Patrul had heard Fernand use multiple blasphemies and

178

the names for many bodily processes in the same phrases – demanding to know what the fuck he thought he was doing. Patrul explained as best he could his predicament but somehow the words for exactly what was on his mind, that the made-up story in Galaxie-Cyclasme was about to become truth with Menaleon as the murderer and he, Patrul, the victim, these words would not quite form themselves in any understandable order.

'What?' demanded Escoto. While the colloquium proceeded, with Patrul mumbling in through the car window at a stony faced team manager, Jacobi was going further and further up the road. He wasn't making an outright bid for an escape because he knew he would have a much better chance of staying away till the end if he and Patrul were sharing the wind, but it was quite clear what Escoto must be telling him, and Jacobi didn't want to hang around if he was going to have to go it on his own anyway.

Patrul said that he would think about it.

'Don't fucking think about it, do as I fucking say. If you ever want to have any self-respect again, get back to the fucking bunch fucking now and haul Sáenz's arse up here as fast as you fucking can.'

Patrul said again that he would think about it, and Escoto, being wise and knowing that in times of great crisis men must determine their own destinies, acted as if to clap him on the shoulder and dropped back out of sight.

Patrul rode on, not striving to catch Jacobi, not resting on the pedals either. He went up Igfuane at an easy lope. Despite the two bursts of intense effort he had put into the race so far, his legs felt good.

And then it happened that through the Temple of Holistic Crap he found himself riding side by side and at the same speed as Stephen Roche. In no huge hurry, Patrul studied the simulacrum. It was a smart piece of ingenuity, and the legs alternately extended and lifted, and the muscles elongated and bulged. But Patrul had seen the reality in his youth when his granddad had taken him to a Pyrenean stage and he knew that Stephen Roche had been gifted with all but the most graceful

style the sport had ever seen, and that beside the flesh most graven things are crap.

He considered now the paragon of human movement. Akil. Why was he not here by his side? Had an unintended insult of Patrul's wounded the great hero so that his resolve, the very meaning of winning had bled out of him? Or was there a more appalling weakness? The image of Baris suffering on the cross on Ventoux came into his mind as the travesty of Roche dived behind the barrier and into the earth. *Compañerismo*. Roche was not in the list of ultimate greats, those upon whose shoulders Sáenz was to sit, but he had been one of two men before Fleischman's reign in Cosimo to win the Giro, the Tour and the Worlds in the same year. And Roche had suffered in that Giro, not just the agony and exhaustion of the race, but the insults and the spit, the cowardly blows that a less-than-nobody can rain down on a man suffering on a bike on a steep mountain pass; he had suffered the abuse of the *tifosi*. So all through the final stages of that race Roche needed to be guarded. A *compañero* rode each side of him, warding off the blows, taking the rancid gob and phlegm of those negatives of men. They had escorted him to victory, and their names are recorded.

At the bottom of the descent, Patrul sat up with his hands on the tops and waited for his friend.

The bunch swept him up like a half-hearted gale. It is perhaps worth recording that while these events were in train, the race had covered a distance of 170 kilometres, Florence to Rome, no stroll.

But now Patrul was himself again, organising victory for Sáenz. He shouted and chivvied together the heroic band who had been confused by the previous turn the race had taken, and they imposed their authority, showing Jacobi's countrymen who tried to take the front and slow things down that the time for tolerance of the second-rate was over. With Akil on his shoulder and his Myrmidons around, Patrul carved a swathe to the head of the peloton, and upped the pace by two kilometres. The weak began to straggle immediately. By the time they were over both climbs it was a

diminished and a heavy breathing bunch which was hunting down Jacobi.

Jacobi's achievement should not be underestimated. True he had benefited from the power and experience of Azafrán, but he had seized the opportunity, his limbs were ablaze, and until Patrul marshalled his team he had continued to pull away. At its greatest his lead was seven minutes. Escoto could tell Patrul that the bunch was now cutting that lead by a minute a lap. They were about to go into the twelfth lap. That still left Jacobi with a comfortable three minute win.

Patrul spoke a few words to his countrymen. There are those who say he also became materially generous beyond the borders of his land, to rivals, with considerable sums judiciously committed. To which he might reply, if he had wanted a sport where only muscle counts he would have gone for something truly brainless, like amateur rowing. But cycling is a mirror of the world. Generosity, human judgement, trust, these things count as much as brute force.

When all was ready Narabellini, who was in his last season and looking to a comfortable retirement, jumped down the right hand side of the road. Patrul made to cover the break, then followed a succession of attempted escapes, of swirls and surges, of one going off the front like a rocket just as another is brought back by a posse of stolid troupers, and so another fizzes and skitters and the head of the course becomes like a complex explosion with squibs erupting willy-nilly. All to cause confusion and uncertainty and wasted breath. But beneath the confusion was a remorseless pattern which Patrul controlled and ordered, ratcheting up the pace a fraction more with each escape, while his countrymen sat in tight formation round Sáenz, conserving him.

When at the beginning of the thirteenth lap the peloton finally regrouped above the lake Patrul disappeared for a while into the thick of it, modest, anonymous, out of the camera's eye. The challenge seemed over. Then, a mere bundle of metres from the top of the climb a figure could be seen from the race helicopter and by millions around the world cutting through the riders like a scythe through barley, and as he

flashed through and off the front once more, Akil, knowing just what was to happen, took his wheel, they hung right round the Chaise together and together, whooping, plunged into the wild flight of La Redondez.

If one were to ask him the question, Patrul would say that that clamorous descent, seized by the huge wind, the bell-like thrum of the tyres on the polished surface, the hurl of gravity as the pair twitched their bikes from one 120 kph curve to its opposite and back again so close that their nervous systems might have been synchronised through the hairs of their arms, that was the true moment of his cycling career, when all its exhilarations were crammed into one.

After that it was over. It was dredging the deepest channels of pain. Akil was there, but not the old Akil. Suddenly Patrul felt his friend's terror at losing transfuse his own entrails like it was way too much adrenalin. It emptied the centre like the fringale and made the breathing more laboured. The horrified fear was not at the loss itself, or even at the shame – for there was no doubt that if Akil did not finish the coming lap as World Champion, the blame would be branded on Patrul's forehead for ever. The fear was a more hopeless one, at the irreversible wasting of muscle, the slackness of skin, teeth lengthening, hair dropping out, and nothing achieved. It was not for himself, this fear, but for Sáenz. Life is indeed a slow transmogrification of zygote into corpse, but Patrul did not want to be made aware of it with quite such inappropriate insistence, on the penultimate ascent of Igfuane. He, he himself felt fine. In agony, desperately exhausted, but that was merely his trade. Otherwise, fine. An ordinary man, climbing in the shadow of a dying giant.

At the top, before them, Jacobi. Patrul took a quick look behind, and saw far away below the streak of the pursuing peloton. Once more, at that time, in his desperate state, who can account for, who can possibly judge the mind of Azafrán? Four times in one race to dredge the will for an abstract strength few can find once in a lifetime. It looked, as he accelerated along the straight and the bell clanged for the last lap, it looked as if he was not riding a race but fleeing a

dreadful fate. The huge crowd heard the despairing cry of Sáenz – like Eurydice dragged backwards into the underworld, one overheated journo wrote afterwards. And then he too, Akil, called on reserves that physically cannot have been there. With a face like Munch's scream he summoned every power in the universe to get back on Patrul's wheel before the tortuous descent.

If before they had gone down with consummate skill, they now dropped with the incontinence of madmen. Only chance kept them from death. They were on to Jacobi half way down the lake. But up the Chaise de Diable Akil began to groan aloud and the sweat poured from his face in rivulets. Jacobi was opening a gap once more. Patrul, who by now could hardly distinguish his limbs from a general anguish, bridged this gap and, between laboured breaths, he spoke.

Cynics say it was more filthy gold. Loyalty, honour, a sense of being able, with your own will, to mould history. Perhaps these things have been devalued by overuse in this record. But, in assessing Akil's victory it is merely requested that the attendant virtues also be taken into account.

The victory was not by commonplace aesthetic judgement glorious. Though up to the last ascent of the Chaise de Diable Jacobi had looked as if he'd kept enough under the saddle to blow Sáenz away in the final sprint, he was only a young man, and his fifteenth meeting with Igfuane broke him. It broke the three of them. By the time they crested the top they looked like the last three survivors fleeing a ghastly battlefield. Akil wavered down the straight like a drunk, and it was only that Patrul and Jacobi were in even worse condition that he crossed the finish first – that, and, finally, the judgement of fate, which must have the last word, because the bunch came across the line, this time not at all like a half-hearted gale, three point five seven three seconds after the man who was now for ever the greatest cyclist the world will ever know, and buried him in a hurricane of colour.

Stage 24

He was on the falling figure even before he hit the barrier, dodging among the finishers as they swirled in. While mechanics and soigneurs helped Sáenz from his bike and took his weight without making it too obvious that he could hardly stand, Fleischman walked backwards and felt Akil over with an insect-like repetition, heart, vastus muscles, inner eyelids, heart again. He tried to keep the attendants in a tight circle round the slumping figure, but Azafrán stayed close by, attentive. His fright over Menaleon had been misguided, and he had been wrong to fear for himself. Akil was the one he had to watch over. Fleischman had become the mantis puppet master with Akil dead meat on the strings.

The podium was set up to one side of the track, opposite the greatest swell of the crowd which had swarmed over the barriers and was now jammed against its base, fifty deep, unable to move for the crush but not worried about that, cheering and shouting to the winners as if they were cousins from the next village.

It has to be with a top professional cyclist that he has an almost instantaneous recovery rate. Maybe he is suffering extreme oxygen depletion at the top of a climb with his muscles burning with lactic acid, but a couple of minutes later he is breathing just so, heart steady like a pendulum. A year ago Akil would have been waving to the crowd as if he had spent the day sleeping in a hammock. Now, Patrul and Jacobi tried to seem like climbing to the platform with the champion's arms slung round their shoulders was great comradeship, but it was hard to hide that the man was in ruins.

And the voice of the crowd altered, to Patrul's ears it was — the fault was in the acoustics of the Temple of Holistic Being, perhaps. The huge sound rolled coldly from the high roof to the distant walls, and he couldn't tell whether it meant love, or anger, or the mechanical applause of hyped indifference. He scanned a hundred faces and no longer he saw cousins, but

dead eyes watching, TV maybe, ugly housewives undressing to the camera, or big awkward animals fucking at the zoo.

Something else caught his attention. Fleischman wasn't where he should have been, with the officials and dignitaries behind the podium. He was in the second or third rank of the crowd and for some reason wanting to look like one of them. Their eyes met, and Fleischman tried to smile.

Patrul became most afraid from that moment, but also cool, like he was moving in a medium where slow cold currents guided his attention between terrors which never quite crushed him. He no longer questioned, he perceived and acted only. Thus, coming in on his right but stuck deep in the crowd, an apparition, the three jolly bandits who had screeched the lewd song of sausages on the Lizarietta, a manifestation now merely noted, not explained; and subliminally sensed – but it was enough to free his attention for the next thing – in the figure of the smallest bandit the aura of a lipstick cop from Andujar, the spirit of a punk chica met briefly in a Northern café.

It has been wondered how to tell the next thing, which was hidden from TV screens 'for legal reasons' though it was captured on a thousand amateur camcorders with the best telephoto and can be downloaded from the net from a hundred different sites. Those dogs' turds who say, 'Azafrán gave it to Sáenz. That much is obvious from what happened next,' may their lying tongues be frozen in liquid nitrogen and welded to their own . . .

Enough.

The champagne magnums, where do they ever come from? It is the lipstick girls who put them in your hands for sure, but somewhere behind it must have been carefully conspired. And so, as Akil's fingers closed, through the roar of the crowd came Fleischman's sudden shriek, 'Look at the cork, Akil.' Patrul saw the movement in Fleischman's pocket, heard the voice of Gabriela Gomelez screech across the distance a wordless command from beneath a bandit's hat, and the three things happening as one he turned to seize the bottle from his friend. Instead like in slow motion, time congealed. He has

186

played it through a million times in his head since then. As Akil Sáenz, World Champion and the greatest cyclist ever known, looked down at the cork of the magnum in his hand, it popped, like a good champagne bottle should, but much louder, so that at the report the cheering died back across the crowd as if the wavefront of an inert gas had spread across a grass fire.

The next short scene was enacted in a world dying to silence.

The cork shot to Akil's forehead with such force that it jerked his head back, and it clung there. It drew behind it a double coil of translucent tube which was, by its writhing, conducting a fluid pumped at very high pressure. Akil's look of dumb surprise quickly became one of agony and terror. But only for a second. Patrul could see the clarity in first one tube and then both turn almost instantaneously to purple-grey.

After another couple of seconds, in a smooth movement as a vacuum cleaner withdraws its cord into itself, the tubes retracted, dragging the cork from Akil's skin and bone and back into the bottle. The head must now have been entirely empty – no matter dribbled from the coin-sized hole in his brow as the world champion, despite Patrul's attempt to hold him upright, pitched onto the planks.

The crowd, even against the crush behind them, forced back as the bottle rolled off the edge of the podium and smashed, revealing a NASA type pump mechanism nestling among the snaky coils. A litre or so of powerful solvent laced with amino acids spreading across the tarmac were all that was left of the seat of consciousness of Akil Sáenz.

Patrul searched again for Fleischman. He hadn't moved. He was seized solid, like he might be a thin statue of horror dressed in human clothes. The crowd too was motionless. But after what seemed like another gap in time, a micro-second, a year, it could be any, Mikkel with sudden ease slipped free of whatever shock had grabbed him. His first blink opened on Patrul, not threatening, not cold. No, he smiled and shrugged like he might be saying, 'Sad, eh? But these things happen.'

Then he took his hand from his pocket and held between finger and thumb a mechanism the size of a coin and, eyes still on Patrul's, threw it far back over his shoulder to be ground into the tarmac by a thousand ignorant feet. Then he shrugged once more, not friends perhaps, but fundamentally on the same side, sorry anyway, and turned to melt into the crowd.

You act sometimes from somewhere you do not know. Patrul has no coherent idea himself of the next sequence, and what he has is confused by dreams. He remembers the rush of air as he hurtled from the platform. He remembers the shards of glass at his feet, and how he chose the longest of them in one flowing movement as the recoil from his landing brought him upright again. He recalls Fleischman, already almost unreachable, his pale face turning as he pushed down the line of least resistance which ran along the low barrier between the real track and the moving belt that carried the kitsch parade of historic cyclists. The crowd there was already less dense. Soon the murderer would be able to walk instead of elbowing through, then run towards the arch of sunlight and up the slip road to his car.

But by then Patrul was running on the moving belt, no recollection of how he got there, in his hand the vitreous blade. The belt had been slowed almost to zero during the presentation so the latex simulacra, yet viler now, creaked and crawled. He would be on Fleischman almost on the instant, and through the barrier between the living and the dead Azafrán would hold his victim's head, tilting up the chin, then turn the lips away and brush instead the racing pulse, lightly, with the glass.

But Mikkel looked round, and saw. He must have calculated that the crowd was still too dense so he too vaulted onto the track and ran between the dummies.

The calculation was imprecise. Patrul was much the faster runner. By the time they got to the tunnel mouth he was onto Fleischman. Now it was just a matter of arranging things appropriately. They stood, the moving track inching them back the way they had come, Patrul swaying his glass dagger like a hypnotist between Fleischman and his escape. From the

black hole came the glorious dead and the high-pitched squeaking of machinery.

It is certain that Fleischman's intellect did not intend him to run into the dark. For a bright and reflective mineral edge to meet his blood halfway, he would have chosen that rather than dive with his body into the underworld, gasping his breath in undignified sobs.

Inside the tunnel it was not quite black. There were dim safety lights and Patrul threw away the glass shard so he didn't slit himself open and dived at Fleischman's staggering form. His quarry fell with his body drooped over the curve of the huge drum which drove the track, but he held the legs and the drum rotated unfalteringly uphill, over seconds restoring them to the horizontal. Patrul pinioned the body, ready to break the arms, but Fleischman was unresisting. He felt like a bundle of dry sticks.

By now Patrul's eyes were more accustomed to the yellow dinge of the hemispheres set at intervals in the walls. They threw faint multiple shadows of the huge chainwheel that turned the gearbox for the track which carried the cyclists of history in their unvarying courses. Because of the gearing the chain snickered onto the toothed wheel, slow and gentle at this lowest speed, in the opposite direction to the way the track moved. As the wheel turned, the angle between teeth and chain diminished to zero, like they do.

Does more need to be said?

Perhaps Mikkel was already paralysed. There was no fight for sure. Azafrán turned the body, moved it to the edge of the track, and rolled it against the flow.

Once it was done, he did not wait. He was acting, not out of hatred; something less diluted by pity.

Immediately the teeth of the chainwheel engaged – the bundle at that moment regained sensibility and the sounds he heard cannot be described – Patrul hurled himself like a suicide over the edge. He twisted his ankle, but such things are only realised later. It was maybe two, three metres fall onto concrete, and he found himself on the edge of another pit, where the belt curved back and into the true dark.

From this inspection chamber were concrete steps leading up to a grey metal door which opened when he turned the lock. The light hit him like an axe.

When his eyes undazzled he saw he was on the real track again, still in the temple but on the edge of sunlight, and out there, up at the end of the slip road where the race vehicles peel off at the finish, was a small but beautiful figure, de Zubia jumping up and down and waving to him. He was finished, but he ran.

As Patrul came up to her Perlita raced round the corner onto the slip road and dived into the Diablo. She revved the engine which was clogged with long idling until the clear shriek echoed back off the walls of the Temple, then span the car ninety degrees and shot downwards onto the circuit.

Behind them, the crowd across the track, the rage of officialdom. Soon the headless thing would come slowly out of the dark and inch past the podium, flesh and blood amongst the latex. There was only one way out.

The horrors of the Diablo's descent of Igfuane are beyond words, and a couple of minutes later the howling slither round the rock of La Baratte impossibly worse than that. When Patrul realised not only was there no alternative to going up La Redondez, but it hadn't even crossed Perlita's mind that there might be a problem, he became philosophical, regretting the shortness of life for Iridacea, squealing happily in her nest behind his shoulders; but content that all three of them would have died, as they might otherwise have hoped to continue their existence, living a full life, unafflicted by ennui, and together.

There was an eyeball-tugging deceleration which suddenly eased, and Perlita seemed to float the car onto the new surface. Then she began to gently accelerate.

Whether it was a genius of engineering intuition, or just a mother's instinct for the preservation of her little one, it is hard to say. Maybe she opted for a synergistic combination of the two developed to their highest imaginable extreme. That's about all that would account for it. By the last curve Perlita was high on the banking, doing the exact 120 for which the

structure was designed. Then she pointed the nose down, accelerating under gravity, and when she was at the mean of the hyperbola she put on opposite lock and eased in the power.

So near and yet so far. Patrul could see the Chaise de Diable calling to them saying, 'I am the solid rock of the planet, come to me.' But at that moment the car, the power being such, went into a drift, holding the mid point of the banking but accelerating and sliding at ten degrees to the way it was travelling. As the speedometer crept upwards there was a crack and then a sort of frizzling, and the Diablo began to vibrate and jitter.

La Redondez Compleja was in terminal rupture. Patrul prepared himself to plummet to the rocks away below. He took a last glance at Perlita, who was working swiftly at the wheel as if she were a racing driver, and there was sweat on her upper lip, and she was looking foolishly happy. At the last second he looked over his shoulder. Iridacea was lying on her back, flailing her arms from side to side and going 'brrrr, brrrr', and over her little body through the slit of rear window he saw the track surface flittering away behind them like the wreckage of a disintegrating air liner as the Diablo, with howling wheels, clawed onto the solid road.

She knew they were for a short while inaccessible, so she parked by the Chaise de Diable to make sure the baby was well stoked and ready for migration. They got out and sat on the wall of the mirador, their legs hanging over the sheer drop while Perlita with her dress down round her waist fed her daughter, smiling in triumph, her breasts ashudder with unrealised sobs.

Away below one of the official race Fiats jerked to a halt at the bottom of La Redondez Ruinada and three figures burst from it in unison. Hired assassins, race officials, a bereft and bitter-sweet police detective from Andujar with her two now conventionally uniformed attendants – it was impossible to tell at that distance. They seemed to be craning up against the sun to where sat the man, the woman and the quietly feeding baby.

Nobody in this world is entirely innocent. Perhaps the time had come to move on. Perlita was about to slide her dark nipple from Iridacea's milky smile but the baby, practically asleep, sucked energetically again. They're programmed every time to expect the next journey will be a long one, babies.

But now looking to the south, they saw a cavalcade of cars, the leading ones with lights flashing, creeping at full tilt along the lake side. In a few minutes they too would begin the climb.

This time Perlita called Iridacea's bluff and withdrew the nipple firmly. The infant slept. They put her in her nest behind the seats and climbed into the Diablo. The engine grunted, and de Zubia surged the car forward, skirted the Chaise and took the fork that led, not round and round the World's circuit, but out of the Cul d'Avenir for ever.

Epilogue

And to return to the world of cycling once more, let it be remembered how Jacques Anquetil finished the Dauphiné Libéré stage race in 1965, had a hasty dinner, and then went on through that night and the next day to win the 600 km Bordeaux-Paris. Let it be remembered not just how Eddie Merckx won more races than any other rider but that, in the 1975 edition of the Tour de France, already beaten in the mountains by Bernard Thévenet, he fell in some trivial mix up in the procession before the start and suffered a broken cheekbone and perforated sinus, and how he still rode on, taking his food mashed and unable to use painkillers because of doping controls, and before Paris took 33 seconds out of Thévenet's lead. How Bernard Hinault rode the last eighty kilometres of Liège-Bastogne-Liège in the snow without a cape, his hands frozen to the bars and no feeling in his limbs, and won by nine and a half minutes.

And also the warm mortals of cycling who are closer to us than the cold gods; how Robert Millar and Eddie Schepers rode either side of Stephen Roche in the Giro to protect him from the kicks and punches of the *tifosi*; how the same happened to Hinault in the Vuelta – and of the honest saint of cycling, that man who perhaps Patrul Azafrán would most like to ride beside when he is not at the shoulder of the great Akil Sáenz, but bowling through the villages of Eden, stopping here and there for a glass of wine and a flirt with a pretty girl, and chatting of this and that, not elevated things, but things as you might see looking out of your window any day in any land – I dedicate the posting of this article to that most human of cyclists, Freddy Maertens.

And finally, standing perhaps by the memorial to the poor and lonely at Tommy Simpson's death when the sun is below the Durance and the crest of Ventoux is a dark shadow, the words of the journalist Antoine Blondin:

'As sports fans, we prefer to dream about angels on wheels,

simon pures somehow immune to the uppers and downers of our own pill-popping society. There is, all the same, a certain nobility in those who have gone down into God knows what hell in search of the best of themselves.

'We might feel tempted to tell them that they should not have done it, but we can remain secretly proud of what they have done. Their wan, haggard looks are for us an offering.'